IMAGES
of America

WINERIES OF THE
GOLD COUNTRY

IMAGES
of America

WINERIES OF THE
GOLD COUNTRY

Sarah Lunsford

ARCADIA
PUBLISHING

Published by Arcadia Publishing
Charleston, South Carolina

Printed in the United States of America

Library of Congress Control Number: 2013933148

For all general information, please contact Arcadia Publishing:
Telephone 843-853-2070
Fax 843-853-0044
E-mail sales@arcadiapublishing.com
For customer service and orders:
Toll-Free 1-888-313-2665

Visit us on the Internet at www.arcadiapublishing.com

For Timothy

CONTENTS

ACKNOWLEDGMENTS

When you see a frog at the top of a pole, all you can wonder is how he got there, because you know he didn't do it on his own; so it is with an endeavor like this book. I have many people to thank for opening up their archives, their histories, and their stories to me as I traveled through the Gold Country searching to tell the story that is embedded in the people of the area.

I am very grateful to everyone who took time from his or her busy life to speak with me. This is by no means a comprehensive list—that would take more room than I have—but I am sincerely thankful to William "Bill" Easton, Ron Erickson, Bob and Dottie Buchanan, Audie Buckler and her volunteers, Amador County vintner and historian Eric Costa, Jim and Pam Costello, Gay Callen, Greg Boeger, Daniel D'Agostini, Ken Deaver, Brian and Diana Fitzpatrick, Ron Gianelli, Lisa Hopkins and her volunteers, Chuck and Jan Hovey, Barbara Kathan, John and Gail Kautz, Stephen Kautz, Melissa La Chapelle, Conrad Levasseur, Jeff Myers, Tracy Neil, Nanette Tanner, Debbie Poulsen, Nikki Reed, Leslie Sellman-Sant, Leon Sobon, Barden Stevenot, Shannon VanZant, Kimberley Wooten, and Ben Zeitman.

I am thankful for my editor at Arcadia, Jared Nelson, for his guidance, expertise, and all-around pleasantness; for my dear friends, who wondered what far-flung location I was going to next and endured the inevitable stories I would fill their ears with that would often start with, "Listen to this, it's amazing . . . "; and last but never least, I am thankful for the loving support of my family, my mom Carol Newell, my son, Timothy Lunsford, and my ever-present Lord.

INTRODUCTION

When James W. Marshall discovered gold in 1848, he changed the face of the area that would become the state of California forever. The cry of "gold!" was heard around the world, and people from all over flooded in looking to make their fortunes. They came from Europe, South America, and Asia to find the pathway to a better life. What they found was hard work slogging away in the mud or in the mines, their dreams of finding gold evaporating in the face of the cold reality that many of them were not going to find the riches they craved.

In the early years of the Gold Rush, those who decided that mining was not for them turned to other endeavors to make a living. Some of them, particularly French and Italian immigrants, brought their dry-farming techniques with them and found that the volcanic and granite-rich soil, similar to that in their homelands, was perfect for growing all sorts of produce, including grapes. As is evidenced throughout human history, where there are grapes, there is wine, and they took those grapes and made wine for both the local and far-flung markets.

Those who mined for gold would mine anywhere they thought they could find the elusive sparkling ore. In Columbia, they even asked the Catholic priest to move the church's location, including the cemetery, when gold was found on its border. The priest did so, moving up to a nearby hill where St. Anne's Catholic Church still stands, but he put his foot down when gold was found on that hill and the miners again asked if the church and cemetery could be moved. Recently, when renovations were done on the foundation of the church, a tunnel was discovered that had been dug from outside the church grounds, presumably by miners who were trying to get around the priest's decision. This disregard by miners for others and their property led to a confrontation with not only the clergy and merchants, but farmers as well. Those who made their living from the land were tired of miners coming and destroying their crops. In 1863, their battle was taken to the courts in *Woodruff v. North Bloomfield Mining and Gravel Co.*, in which the judge ruled that miners were not allowed to dig for gold underneath property that was already planted.

The ruling directly affected the farming community, including those who had already discovered that the area was perfect for growing vineyards and making wine. One Swiss immigrant, Adam Uhlinger, planted his first vines in order to keep miners from tearing up his land in the Pigeon Creek area of what would become the Shenandoah Valley. It is hard to imagine that others did not do the same.

The Gold Rush produced a transient society of sorts, with miners traveling from one area to another, setting up mining camps that were wild and raucous, and then moving on when the diggings proved to be spent. It was the merchants and those who provided lodging and food to miners and travelers alike who truly made a fortune.

Many miners saw the opportunity to make another kind of gold in business, setting up hotels on well-traveled roads where the weary could rest for the night and refresh themselves with a meal and good glass of wine. Not all of them were worth the price paid to stay in them, but there were clean, well-run establishments that provided fond memories for those who visited. "After all we

7

mainly consider the value of an inn by the quality of the food, drink and goodness of beds that it affords," wrote an unknown traveler who frequented the Sierra Nevada region and its inns. "But thank heavens there are exceptions to the variety of houses above last mentioned. Exceptions which after being enjoyed, memory loves to cherish."

Other business-minded individuals found opportunity elsewhere, and nurseries began to open to provide those who wanted to garden for their own household and/or commercially with the rootstock and plants for their agricultural endeavors. Louis Miller, who opened a nursery near Auburn, brought wine grape rootstock from America and Europe to the foothills and his own red and white table wines for sale. Nurseries were also located around Stockton and Sacramento.

When the gold ran out, the population dwindled, and those who chose to stay began to look for other ways to make a living in earnest. The area quickly went from an economy based on mining to one based on agriculture, which included wine making. By the 1870s, the area was becoming well noted as a wine district. By the late 1800s, El Dorado and Calaveras Counties ranked third and fourth in wine production in the state of California. "This mountain belt has now about 6,000,000 vines, and at this rate of increase will soon become the chief wine district of California," the San Francisco–based *Daily Alta California* reported in January 1870.

The report proved to be premature. By the early 1900s, the area declined because of a poor local economy and dwindling population. This coupled with Prohibition would effectively decimate the wine industry in the region.

The Volstead Act, commonly known as Prohibition, was almost a century in the making, culminating in the 18th Amendment to the Constitution, which went into effect January 17, 1920. With its restrictions on the manufacture, sale, and transport of beverages containing over 2.75 percent alcohol, its allowance for households to make 200 gallons a year for personal consumption, and its nod to those who used wines in their sacramental services, the enactment of this amendment ushered in a new wave of American life.

In the foothills, the wine industry was already tottering when the Volstead Act was voted on and enacted, and its passage effectively stopping the wineries and their commercial endeavors in their tracks.

Some vineyards were able to stay afloat during this time selling their fruit to home winemakers, and many wineries did stay open during Prohibition, albeit flying under the radar so to speak. In 1933, when the Cullen-Harrison Act, which was the 21st Amendment, repealed the 18th, the change ushered in a new set of government regulations overseen by the Bureau of Alcohol, Tobacco, and Firearms. New licensing and bonding requirements, along with their high price tag, effectively shut down surviving wineries, because they found they could not afford the new cost of doing business.

A handful of wineries did make a go of it, with only one surviving and continuing into the 21st century under new ownership: the D'Agostini Winery, in the Shenandoah Valley, which has its roots in the Uhlinger Winery.

After Prohibition, the region became quiet as far as commercial winemaking was concerned. What Prohibition started, phylloxera finished, and only a few vineyards still produced fruit for sale. Many other vineyards decimated by the phylloxera infestation were torn out and replaced by orchards and crops that would provide much-needed economic viability for farmers, such as the pear orchards in the northern part of the region near Placerville and Auburn.

Those who remember the 1970s may remember *Star Wars* and Studio 54, not the beginning of a wine renaissance in the foothills. But that was just what began to happen with the arrival of entrepreneurial men who, like the some of the miners of old, saw that the land was perfect for growing vineyards and making wine. They took the risk of making wine in an area that was no longer considered a wine region, changing the landscape of the area in much the same way the miners did during their quest for gold but shaping it to produce a yield that has lasted far longer.

The forerunners of the wine revival included Boeger Winery to the north; Montevina winery, now known as Terra d'Oro Winery, in the Shenandoah Valley; Stevenot Winery in Murphys; and Yankee Hill Winery in Columbia.

That first wave of winemakers was followed by others, some with deep roots in the region: the Kautz family, founder of Ironstone Vineyards in Murphys, where Gail Kautz's grandfather worked as a mining engineer at the Carson Hill Mine; and Ron Gianelli, founder of Gianelli Vineyards in Jamestown, whose great-great-grandfather, an Italian immigrant, not only grew vineyards but was also a Tuolumne County supervisor.

The impact of wineries is not only evident in the landscape, it is also felt in the local economy, where they create employment opportunities and bring in an extra layer of tourism to a region that is already rich in that regard. The Gold Country boasts not only its deep, rich history as an attraction but also destination spots like Calaveras Big Trees, Chaw Se Indian Grinding Rock State Park, and Railtown 1897 State Historic Park. It is also bordered by national forests full of outdoor activities, including hiking, skiing, and rock climbing.

Now, more than ever, as you drive through the Gold Country, you can see rows of meticulously kept vines that blanket the hills with their unique telltale branches and colorful leaves that sprout green, then gold and red, throughout the seasons.

The Gold Country winemaking endeavors seem to have come full circle. Like the days before Prohibition, there are hundreds of wineries in the area again. They have stepped on to the national—and sometimes international—stage with their award-winning wines, combining their winemaking skills with the history of the area.

One

TAKING ROOT

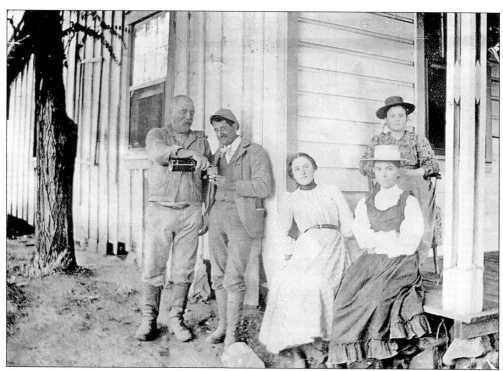

During the Gold Rush, many wineries sprang up, making wine for both household and commercial use. Here, Angelo Sciaccaluga holds a bottle of wine for a friend in the 1870s. Sciaccaluga opened his winery in Vallecito. Later, his great-grandchildren would follow in his footsteps, opening Tanner Vineyards in Murphys. (Courtesy of Tanner Vineyards.)

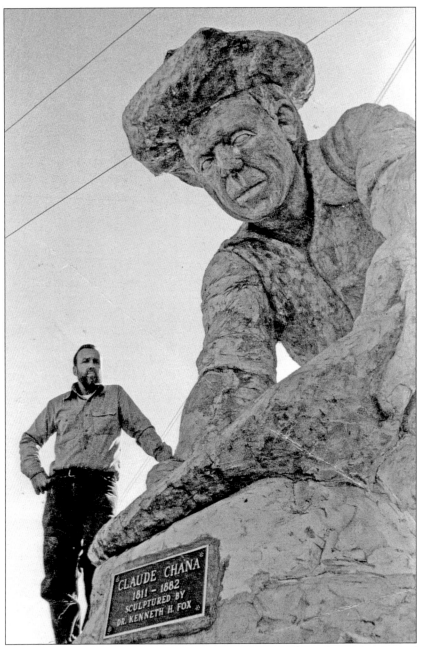

Credited with being the first to find gold in Placer County in the Auburn Ravine on May 16, 1848, Claude Chana holds a special place in the history of the Gold Country. A native of France, Chana worked as a cooper. Like many of those who came to the area and did well, Chana saw opportunity in more than mining. He planted peach pits, almonds, pear seeds, plum pits, and 200 grape cuttings from Mission San Jose along the Bear River on the Sigard Ranch, which he would eventually buy for $6,000 in gold. Successful in his agricultural endeavors, he was listed as a winemaker in the 1880 census and produced 10,000 to 12,000 gallons of wine annually. He is honored in the area with this statue in the city of Auburn, sculpted by Dr. Kenneth Fox, pictured here standing next to his creation. (Courtesy of Placer County Museums.)

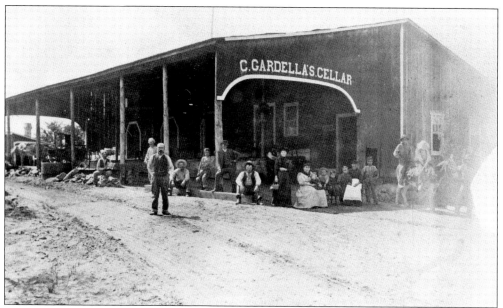

Gardella's Cellars was founded by Charles Gardella and was one of many wineries in Calaveras County that contributed to the area being the fourth-largest wine-producing area in the newly minted state of California. "Mr. Gardella has established that cultivation is better than irrigation, and has the pride of Calaveras in the shape of a vineyard," said Anthony Caminetti in 1887. Caminetti was a prominent viticulturist and politician in Amador County. (Courtesy of Calaveras County Archives.)

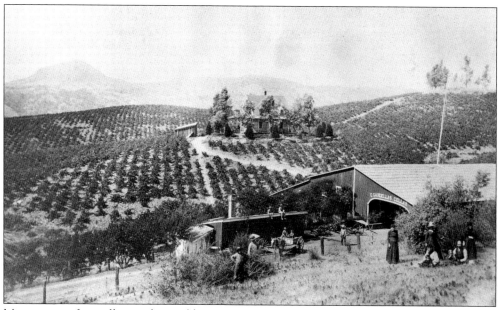

Miners came from all over the world to make their fortunes during the California Gold Rush. Many immigrants of Italian descent, like the Gardella family, found the area and climate very similar to the hills of their homeland and began to plant vineyards. The Gardellas had extensive vineyards and a winery in the thriving Gold Rush town of Mokelumne Hill. (Courtesy of Calaveras County Archives.)

As agricultural endeavors took off, people needed a place to buy their basic stock. Louis E. Miller of Rattlesnake Bar not only planted 10,000 vines of his own and made wine, he also began importing vines from the East Coast and Europe to sell. In a January 24, 1863, ad in the *Placer Herald*, Miller wrote, "My Wines and Brandy will be found of superior quality for family use and medical purposes." As this advertisement that ran a year later shows, he would sell the nursery business with all his nursery stock, including American and European grape stock, with detailed lists of the varieties being sold. (Courtesy of Placer County Museums.)

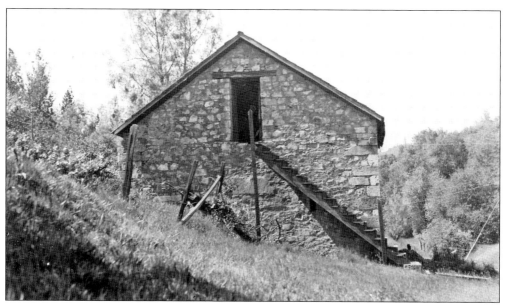

Many wineries, like this one in Happy Valley, dotted the rolling foothills of the Sierra Nevada during the Gold Rush. After the Civil War, El Dorado County and Calaveras County were the third- and fourth-largest producers of wine and wine grapes in the state of California, trailing Los Angeles County and Sonoma County. (Courtesy of Calaveras County Archives.)

Early in the Gold Rush, many immigrants found that they made far more money selling supplies and food to miners than they did mining. Near Placerville, French settlers maintained gardens dubbed Jardin Francias, which changed hands a few times before an emigrant from Genoa, Giovanni Napoleon Lombardo, purchased the area and began planting vineyards. Here, the land deed shows one of the transfers to Peter Le Carre. (Courtesy of Boeger Winery.)

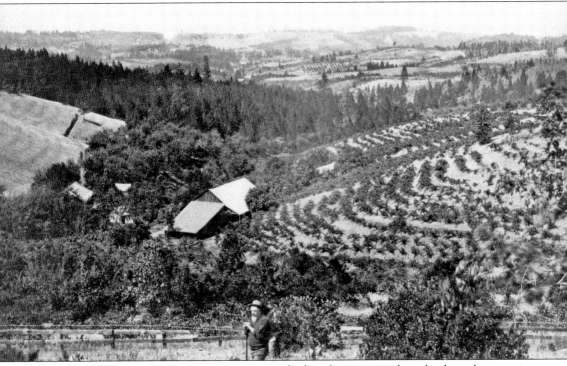

In 1855, the California State Legislature passed a law that exempted newly planted grape vines from being taxed for four years. This produced an increase in vines planted, with the number of El Dorado vines jumping from 24,000 in 1856 to 77,500 in 1858, and in Tuolumne County the number of grape vines went from 7,000 in 1857 to 50,000 in 1858. Not all of these grapes went to local wineries or winemakers; some of it went to other wineries in the newly minted state of California, where the wine industry was booming. Here, Giovanni Lombardo stands in front of his vineyards near Placerville. (Courtesy of the Boeger family.)

The Lombardo family stands in front of the winery in 1885. Giovanni (left) and Candida (center) are pictured with their only child, Sarah, holding her son John Fossati, who would eventually take over the winery operations. When the house was built around 1872, a six-year-old Sarah helped carry rocks to build it. The historic house can still be visited at the Boeger Winery. (Courtesy of the Boeger family.)

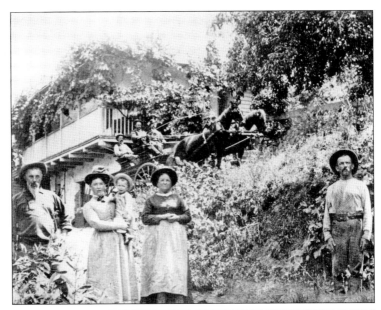

Giovanni Lombardo (far right) came to the gold fields in 1856, visiting the world-famous Calaveras Big Trees and spending a week in San Andreas before going on to settle near Placerville. There, he bought properties with an eye to farm, raising fruits and vegetables and growing vineyards. He made a large variety of wines and brandies and furnished sacramental wine to the Catholic Church. Here, he and his wife, Candida, stand with friends outside their home in 1905. (Courtesy of the Boeger family.)

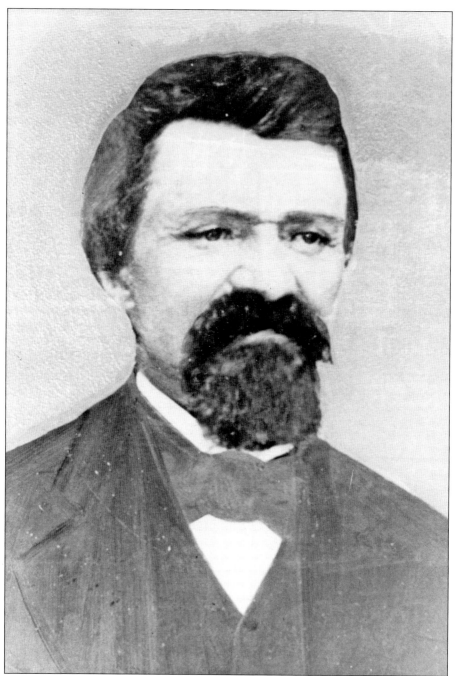

One of the earliest known winemakers in the Shenandoah Valley was Swiss immigrant Adam Uhlinger, who settled in the Pigeon Creek area of the valley in 1856. By 1867, he was listed as a vine grower in the registry of voters. He grew mostly Zinfandel grapes, also known as Black St. Peters, and was making wine by 1869. He planted his first rows of vines to prevent miners from looking for gold on his winery property. The court's ruling in *Woodruff v. North Bloomfield Mining and Gravel Co.* protected those who were actively engaged in agricultural pursuits from miners who wanted to dig under their land for gold. (Courtesy of the Sobon family.)

Wine reports from the Gold Country regularly made the vineyard reports in San Francisco's *Daily Alta California*. "The Zenfentbel [*sic*] grape is praised very highly by all who have cultivated it. Grape growers in Tuolumne, El Dorado and Placer counties speak as well of it as those in Napa and Sonoma," the August 19, 1867, edition reported about Zinfandel. Here an unidentified man and boy work a vineyard. (Courtesy of Amador County Archives.)

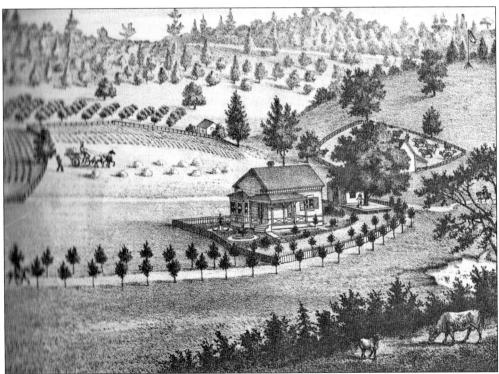

"Hill and mountain sides in no way superior to ours when the quality of the soil is considered, have lent success to Napa, Sonoma and Livermore wine districts. . . . Still we are constantly being told it cannot be done," said Anthony Caminetti at the Agricultural Fair in Ione in 1887. Caminetti was an ardent supporter of viticulture in the area and probably had the largest vineyard in Amador County during that time. Pictured here is his Springdale Ranch near Jackson. (Drawing from *History of Amador County*.)

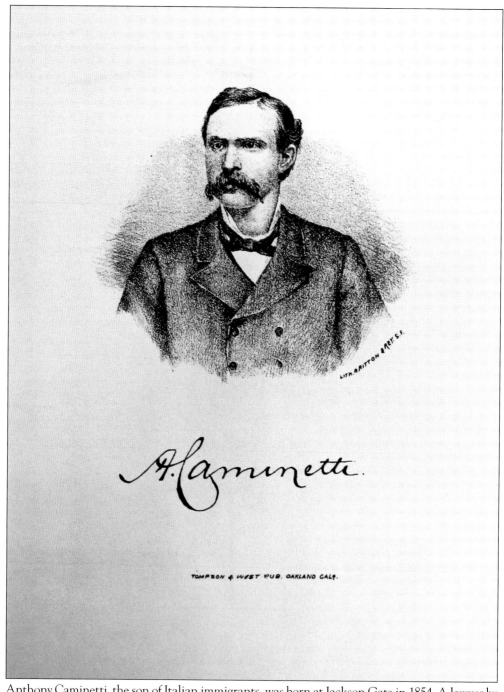

Anthony Caminetti, the son of Italian immigrants, was born at Jackson Gate in 1854. A lawyer by profession, he practiced in San Francisco before returning to Jackson, where he not only planted 100,000 rooted vines and cuttings of domestic and foreign varieties of wine grapes but also began a political career that took him from local district attorney all the way to Congress, to which he was elected in 1890. (Courtesy of Amador County Archives.)

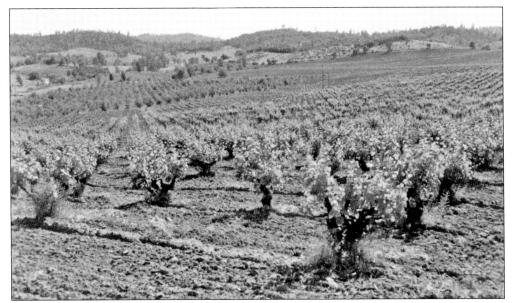

The Shenandoah Valley near Plymouth was not the only place in Amador County where winemakers were profiting. August Legendre began farming 120 acres in 1880 near Fiddletown and by 1879 had produced 1,000 gallons of wine. Over 30 years later, vineyards could still be found in the area. Here, a vineyard of an unknown owner shows the extant of some of the wine grape crops in that area. (Courtesy of Amador County Archives.)

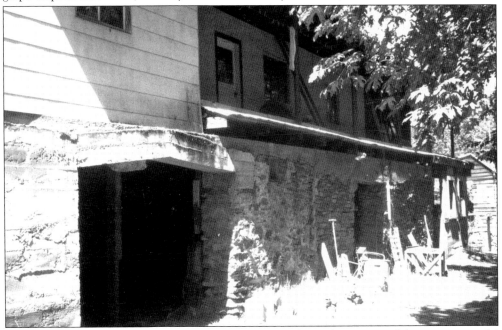

The Douet Ranch, also known as the French Garden and Ranch, was one of the most successful early wineries. In 1863, French immigrants Andre Douet and Marie Suize, who would go on to become known as Madam Pantaloon for wearing pants and boots in an era when women only wore dresses, began working the property between Clinton and Jackson that would eventually produce 10,000 gallons a year. (Photograph by Eric Costa, courtesy of Amador County Archives.)

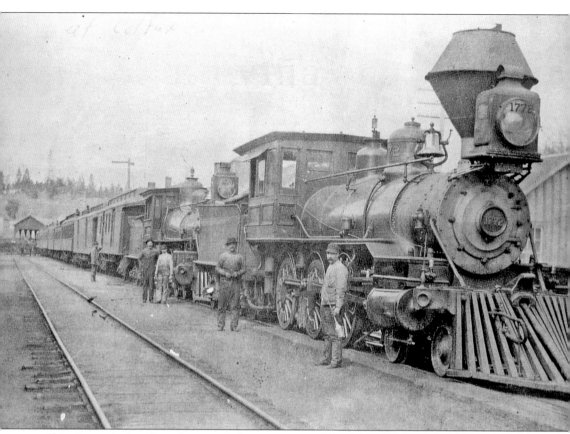

Shipping agricultural products, including wine, out of the foothills region could be problematic because of the area's terrain. The northern region had more access to ship its products out because of the railroad that ran through the area to the east. Here, railroad men pose with a Central Pacific train in Colfax around 1891. (Courtesy of Placer County Museums.)

When the world rushed in and the quest for gold was all that mattered, areas that provided a relatively easy passage across rivers sprang up, and business-minded men did well running ferry businesses. One of those communities, pictured here in 1850, was Robinson Ferry, which later became Melones, along the Stanislaus River. (Courtesy of the Bureau of Reclamation.)

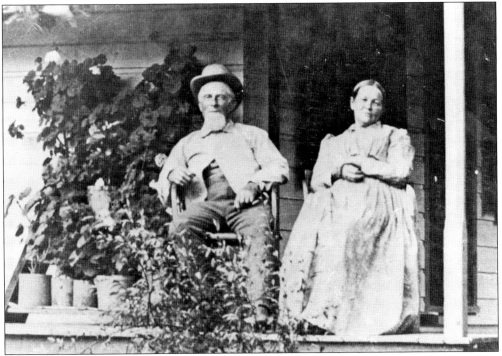

Harvey and Adelaide Wood sit on the porch of their home in Robinson Ferry in the late 1800s. Harvey Wood bought the ferry from John W. Robinson in 1856. Wood is credited with starting the town of Robinson Ferry after he bought the ferry. He came to the area on foot from Massachusetts, arriving in 1849. (Courtesy of the Bureau of Reclamation.)

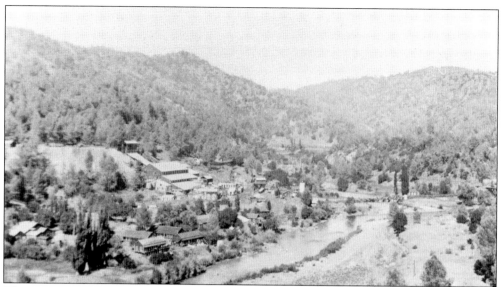

The community of Robinson Ferry was renamed Melones in 1902. It was an important crossing point on the Stanislaus River for travelers and for miners seeking their golden fortunes. Just 13 years after the Robinson Ferry began taking people back and forth across the river, the town had two saloons, a restaurant, three general stores, a community hall, a hotel, and several gaming establishments. (Courtesy of the Bureau of Reclamation.)

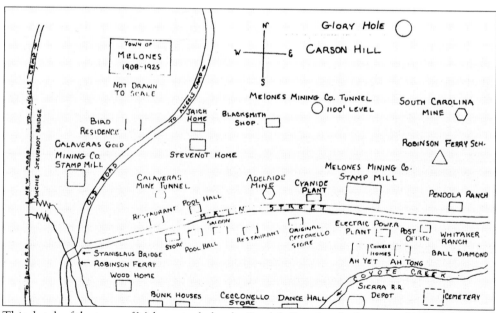

This sketch of the town of Melones includes the Pendola Ranch, which was established about the same time as the town in the 1860s. Pendola Ranch supplied the miners with eggs, milk, fruit, vegetables, and wine from its vineyard. In a good year, it produced about 3,000 gallons of wine. (Courtesy of the Bureau of Reclamation.)

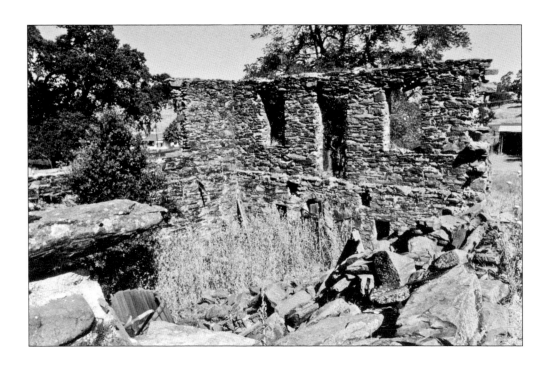

By 1866, the Froelich Winery, built of stone by brothers Gustavus and Charles near Jackson in what is now Martell, produced 8,000 gallons of wine. The same year, Gustavus gave a bottle of wine to the local newspaper, the *Dispatch*, which wrote, "It was never excelled by any ever imported from any part of Europe." (Photographs by Eric Costa; both, courtesy of Amador County Archives.)

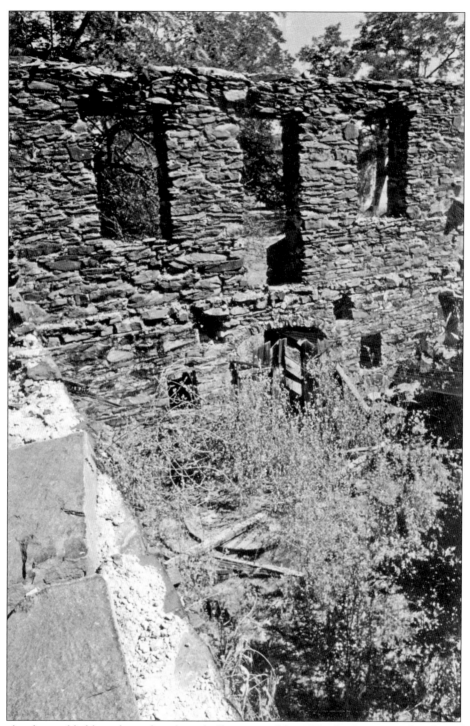

The brothers added brandy to their list of offerings, and by 1873, the *Sutter Creek Independent* reported that the Froelich vineyard was one of the best in the state. Now, all that is left of the winery and the vineyard are these stone walls. (Photograph by Eric Costa, courtesy of Amador County Archives.)

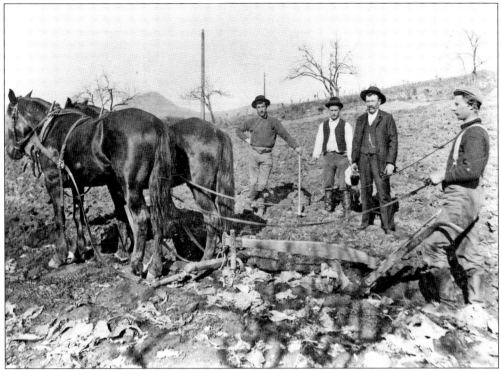

During the rush for gold, settlers came from all over the world. Those with a background in agriculture soon learned that the soil was rich for planting fruits and vegetables. Some not only grew food for themselves and their families but also found that selling their produce was more lucrative than mining. Here, a ranch hand is plowing the soil in preparation for planting a vineyard on the Gardella family property. (Courtesy of Calaveras County Archives.)

Vineyards were grown all over the Sierra foothills when immigrants came to the area in search of gold. Many wineries sprang up around towns, and winemakers used the grapes for their own wines and also sold grapes to other winemakers. The Gardella Winery was founded by Charles Gardella in Mokelumne Hill. (Courtesy of Calaveras County Archives.)

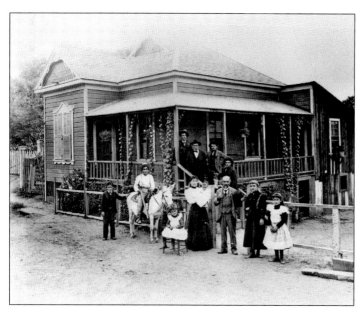

Italian immigrants brought their grape-growing skills with them to their adopted country. Because the soil and environment is very similar to the wine region of Italy, those who planted vineyards and made wine found the business more lucrative than panning for gold. The Gardella family, pictured here in front of their home in Mokelumne Hill, was one that prospered in this endeavor. (Courtesy Calaveras County Archives.)

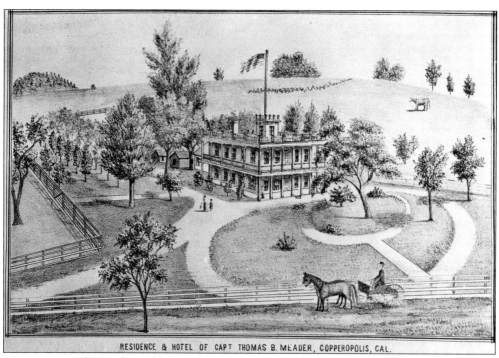

RESIDENCE & HOTEL OF CAPT THOMAS B. MEADER, COPPEROPOLIS, CAL.

Many times, settlers in the Gold Country mined for their fortune and worked for their living. Here, the property of Thomas B. Meader in Copperopolis is a summer resort with, according to *Calaveras County: Illustrated and Described Showing Its Advantages for Homes*, "fine views" of the surrounding countryside, including his orchards and vineyards. (Courtesy of Calaveras County Archives.)

Members of the Gardella family, prominent in winemaking in Mokelumne Hill during the late 1880s, pose for a portrait. (Courtesy of Calaveras County Archives)

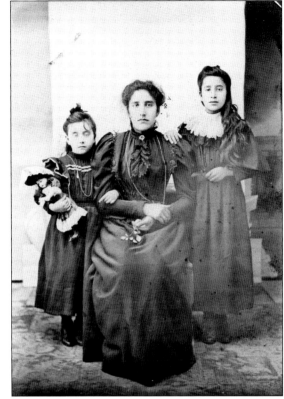

Winemaking was a lucrative business during the late 1800s, allowing those who made profits from the business to enjoy a nice lifestyle. Here, members of the Gardella family relax with friends at the home of William Burleson. (Courtesy of Calaveras County Archives.)

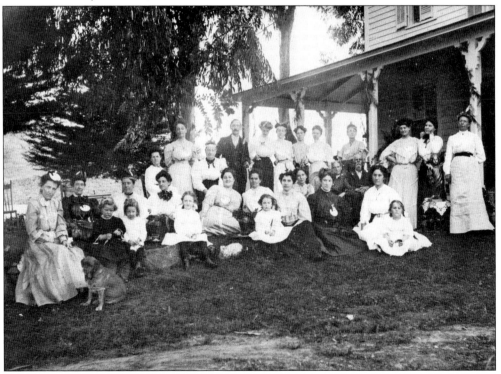

The Uhlinger Winery was the 2,459th winery to be bonded in the state of California. Being bonded allowed the winemaker to do more than sell grapes; he or she could also sell wine commercially. By 1868, there was quite an increase in the quantity of California wine made. According to the state surveyor general's report, 2,587,764 gallons were made statewide, which was an increase of 700,000 gallons from 1867. Six of the 12 top producing counties were in the Mother Lode region: El Dorado, 168,688 gallons; Amador, 129,998 gallons; Calaveras, 55,132 gallons; Placer, 51,300 gallons; Tuolumne, 50,397 gallons; and Butte, 30,828 gallons. (Both, courtesy of the Sobon family.)

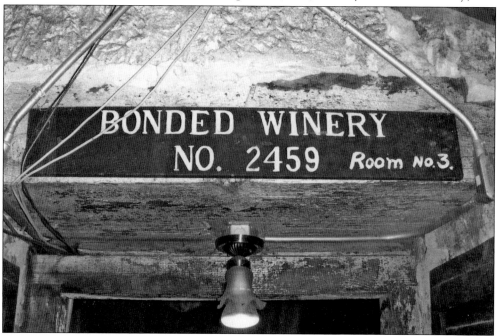

Some Californian wine was made from Mission grapes, which were considered inferior in quality to Zinfandel, Black Malvoisie, Reisline, Golden Chasselas, Rhenish Muscatella, and other varieties. (Courtesy of the Sobon family.)

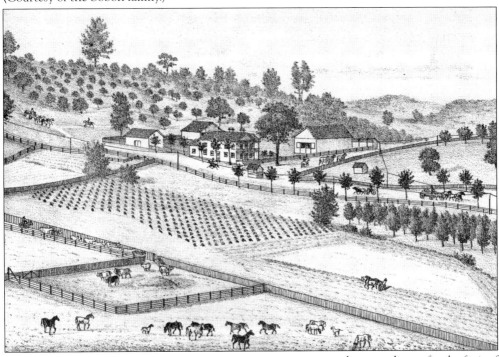

Exhibiting and entering wine in competitions is one way to gain a larger audience for the fruit of the vine. Early on, winemakers were exhibiting their wines beyond the borders of the Mother Lode. John H. Grambert and his father-in-law, Matthew Wells, bought and began operating the Central House, a well-known stopping place for weary travelers near Drytown, in 1863. They also planted vines and made wine. In 1872, they showed an 1866 white wine at the state fair in Sacramento. This is the Central House Ranch in 1880. (Drawing from *History of Amador County*.)

Much of the wine made in California was of marginal quality because of a lack of education about growing and the reality that many of the vineyards in the state were being grown in unsuitable soils. This was not so in the Gold Country. The *Daily Alta California* reported in August 1867, "The general quality of the wine made in the Sierra Nevada is better than that made in the low land of the valley," although that wine was held by a multitude of people in small quantities of diverse quality, which made it difficult for merchants to obtain a steady supply of good wine from year to year. This hillside vineyard was located near the Mokelumne River. (Courtesy of Amador County Archives.)

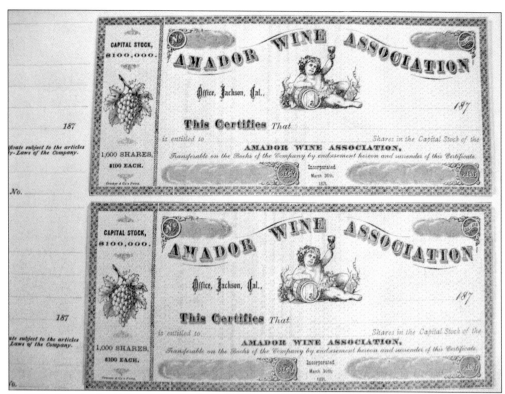

By 1870, Amador had 15 wineries producing 58,000 gallons of commercial wine annually. In March 1871, the Amador Wine Association was formed for the purpose of supporting local winegrowers. Stock was sold to support the organization, but it seems to have failed in its endeavor, as not much was heard about it after it was incorporated. (Courtesy of Amador County Archives.)

Giovanni "John" Gnecco was the first bonded distiller/winemaker in Calaveras County. He took a wagon of wines, brandy, canned fruits, and vegetables to mining camps throughout the year. In winter, he placed heated bricks in gunnysacks next to his feet to keep warm. According to Alice Burton, one of his renters, he had two beliefs he lived by: "never injure anyone" and "observe nature." (Courtesy Barbara Kathan.)

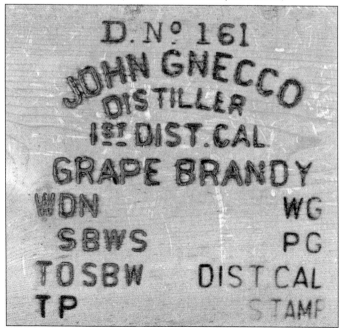

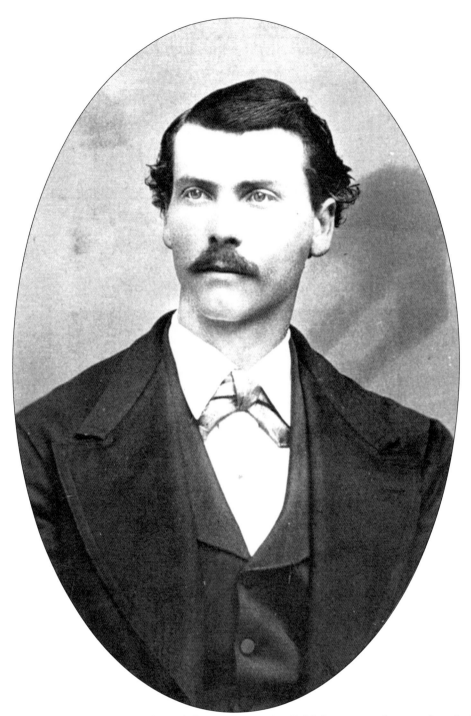

At the age of 13, John Gnecco braved the journey to the Gold Country on his own from Italy, traveling across the Isthmus of Panama, a journey of four to six days of arduous travel on foot. He left behind the possibility of life in the Catholic priesthood, where his family had placed him at the age of six before they came out the California Gold Country. Eventually, he would open the first bonded distillery in Calaveras County. (Courtesy of Barbara Kathan.)

Louisa Charlotte Lagomarsino married John Gnecco in 1881. Arranged by Louisa's father, Agostino Lagomarsino, there was a 16-year age difference between the two: Giovanni was 31 to her 15. The two worked hard on their farm and winery, raising seven children and giving them all American names. Here, Louisa sits for a portrait later in life. (Courtesy Barbara Kathan.)

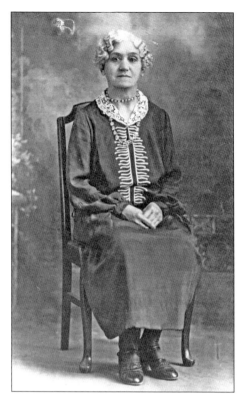

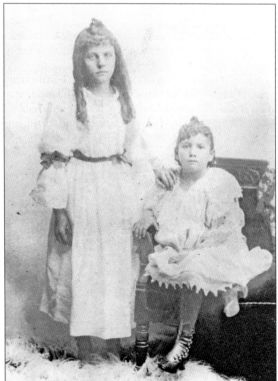

Many immigrant families enjoyed traditions that reminded them of their homeland. Here, the daughters of John and Louisa Gnecco stand for their portrait. Eventually known as Grace Gracelda Gnecco Tiscornia (standing) and Norma Adele Gnecco Foppiano Howard, the two were very musical. Grace played the guitar and the piano and Norma sang. Music was often played in the Gnecco home, reminding the family of their Italian heritage. (Courtesy of Barbara Kathan.)

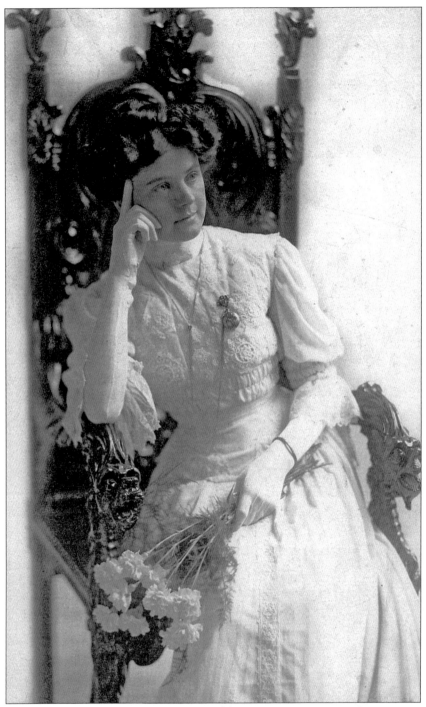

John and Louisa Gnecco's daughter Grace Gracelda Gnecco Tiscornia sits for a portrait in her wedding dress. When she was a young girl on the farm, she convinced her younger brother to get into their father's wine, and he got so sick that they had to walk him up and down the street to sober him up. According to the family, he never touched a drop again. (Courtesy of Barbara Kathan.)

Irish-born Stephen Finn arrived in the Gold Country through Canada. In 1853, he and his French-Canadian wife spent a few months in Mud Springs before settling on the Sacramento Road three and half miles west of what would be Plymouth. Besides operating a successful roadhouse in 1869, he began planting vineyards and making wine. By the late 1870s, his cellar could hold up to 30,000 gallons of wine, which was reported to be some of the best in the state. (Courtesy of Amador County Archives.)

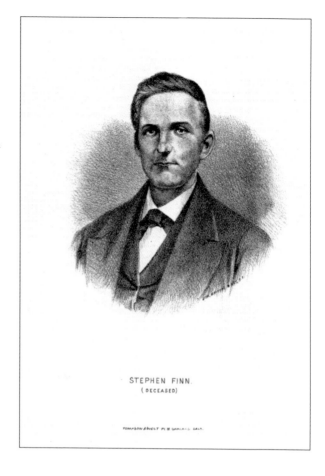

STEPHEN FINN.
(DECEASED)

JOHN POST'S VINEYARD

Like postcards of today, in the 1900s postcards and stationery often gave those who received letters from a traveler a glimpse into the location where the letter-writer was staying. Here, John Post's vineyard is featured on promotional envelopes for Sutter Creek. The South Eureka Mine and the Sutter Creek Grammar School were also featured on this set of envelopes from the early 1900s. (Courtesy of Amador County Archives.)

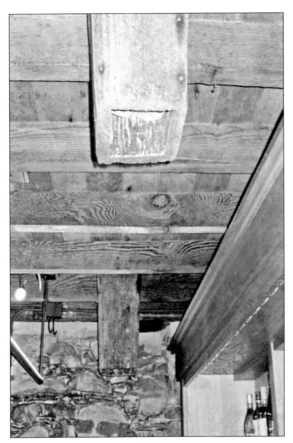

During the Gold Rush and beyond, those who had wineries often used their houses in their winemaking endeavors. Here are chutes that go from the living room to the cellar in the historic Lombardo house at the Boeger Winery in Placerville. In the 1800s, the family would bring the grape crusher into the living room, positioning it so the juice would go down these chutes into barrels in the basement. (Both, author's collection.)

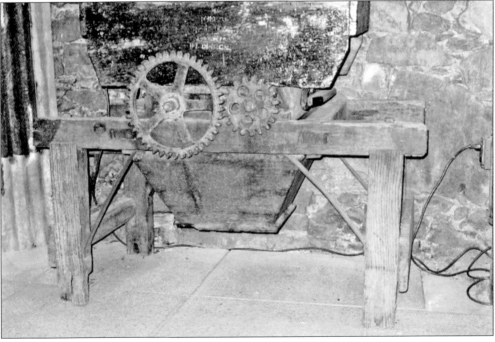

French native Theodore Sigard's influence on the winemaking community was great. Grape cuttings from Mission San Jose were planted on his ranch in Bear River. These were thought to be the first grapes planted in the Auburn area. (Courtesy of Placer County Museums.)

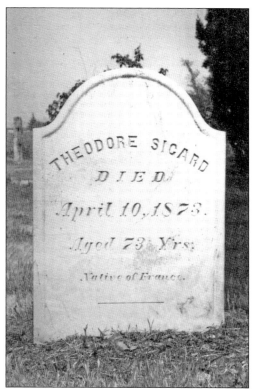

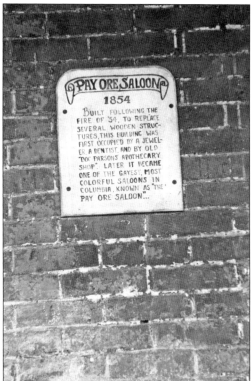

Buildings in a Gold Rush town often housed many different establishments. This building, erected in 1854 in Columbia, housed a jeweler, a dentist, and an apothecary before it became the Pay Ore Saloon. The miners worked hard and played even harder. Known for their hard-drinking ways, they imbibed not only spirits but wines too. (Courtesy of the Bureau of Reclamation.)

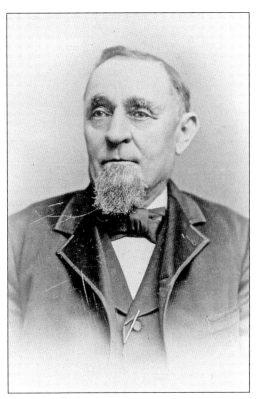

Like other mining tent cities, Mormon Island in what is now Folsom flourished during the Gold Rush and by 1853 had a population of about 2,500. Pictured here in the 1870s, John B. Studarus was one of those who came to Mormon Island. He mined there in 1853 and made enough to purchase 349 acres at Mills, where he was a rancher and viticulturist, in 1854. (Courtesy of Placer County Museums.)

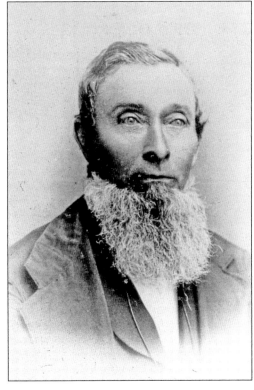

Located where the North and South Forks of the American River join, Mormon Island was once a mining camp and is now under water. En route between Sutter's Fort and Sutter's sawmill at Coloma, a group of Mormons set up a mining camp there six weeks after the discovery of gold. Pictured here is Powell F.T. Hart, a miner at Mormon Island in 1854 who later became a rancher and viticulturist. (Courtesy of Placer County Museums.)

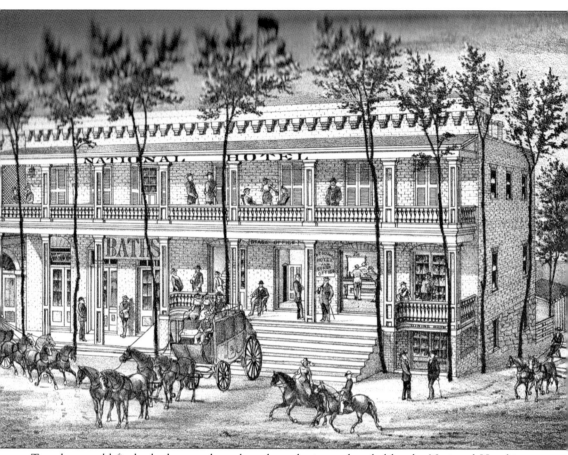

Travelers could find a bed, a good meal, and good wine at hotels like the National Hotel in Jackson. "The traveller in the mines is not unfrequently astonished to find in some hotel in a little country town better wine on the dinner table than he would find at first-class restaurants in San Francisco—that is unless he ordered some high priced brand," reported the *Daily Alta California* of August 19, 1867. (Photograph from *History of Amador County*.)

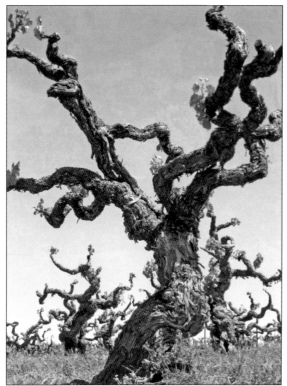

Vineyards were planted in California before it became a state, with many of those being Mission grapes. These grapes were brought to the state as a result of the efforts to spread the word of Christ through Franciscan and Jesuit priests and Fr. Junipero Serra's Spanish missions. The grapes were used to make sacramental wine, table wines, and Angelica at the 21 California missions. Their origin was a mystery until 2007, when it was discovered by a team of Spanish researchers that the grape comes from a little-known Spanish variety called Listan Prieto. Deaver Vineyards in the Shenandoah Valley maintains six acres of Mission vines, part of the original vineyard planted by John James Davis in 1870. (Both, courtesy of Leslie Sellman-Sant.)

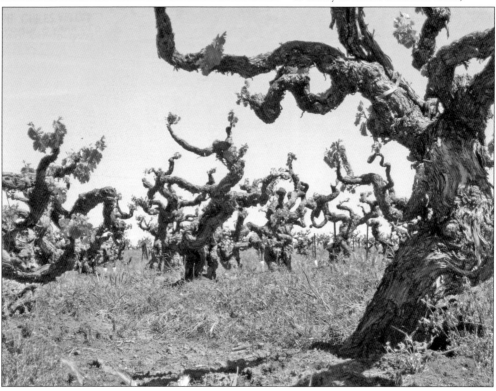

The western Sierra wine belt extended 100 continuous miles and by 1867 boasted six million vines. The *Daily Alta California* reported in 1870, "At this rate of increase will soon become the chief wine district of California." Just over a decade later, John Gnecco would add to that number when he terraced land in Jesus Maria to begin planting grapes and making wine and brandy. (Courtesy of Barbara Kathan.)

Giovanni Gnecco, also known as John Gnecco, delivered wine, canned fruits, and vegetables to miners in the gold camps. Like many who made their living off the land, he was a hard worker. Here, his wife, Louisa Lagomarsino Gnecco, and his brother Frank Gnecco stand in front of the family home in Jesus Maria. (Courtesy of Barbara Kathan.)

Mining and grape growing existed hand in hand during the Gold Rush. The Zinfandel and Barbera varietals were particularly popular with the miners, and often vineyards were planted near mining operations. This is the town of Jesus Maria. (Courtesy of Barbera Kathan.)

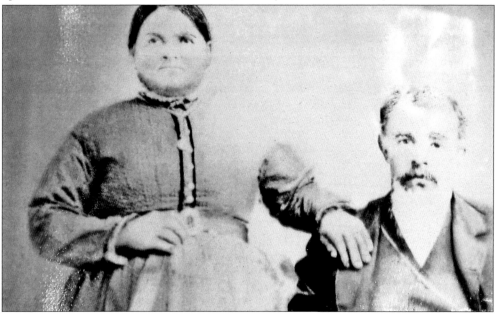

Giovanni Napoleon Lombardo took gardens that were started by French immigrants and expanded them to include vineyards. He terraced a valley near Placerville, planting Zinfandel and Mission grapes, and developed a winery that would allow visitors to Boeger Vineyards in the 21st century a glimpse into winery life in the 1800s. Here, Giovanni poses for a portrait with his wife, Candida. (Courtesy of Boeger Vineyards.)

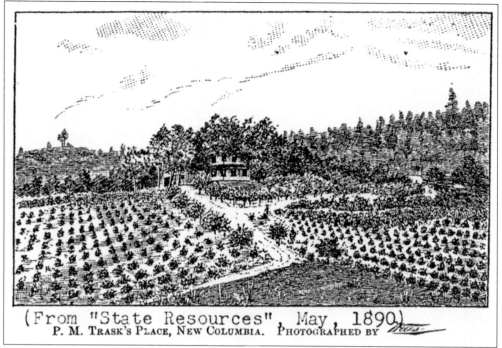

(From "State Resources", May, 1890)
P. M. TRASK'S PLACE, NEW COLUMBIA. PHOTOGRAPHED BY *Wells*

Although long gone, the presence of some vineyards like those of Prentiss M. Trask can still be seen today. Trask arrived in Columbia from Maine in 1852. He mined in the Coral Gulch area before turning his attention to farming a little north of the town. He eventually planted 25,000 vines and six acres of fruit trees, using dry-farming practices that were new to the area at the time. Today, a terraced area near Gold Springs Estate outside Columbia gives passersby a chance to see where the vineyards were located. (Courtesy of Columbia State Archives.)

During the Gold Rush, the enormous stamp mills like this one in the town of Melones could be heard crushing ore to find the precious gold contained within. (Courtesy of the Bureau of Reclamation.)

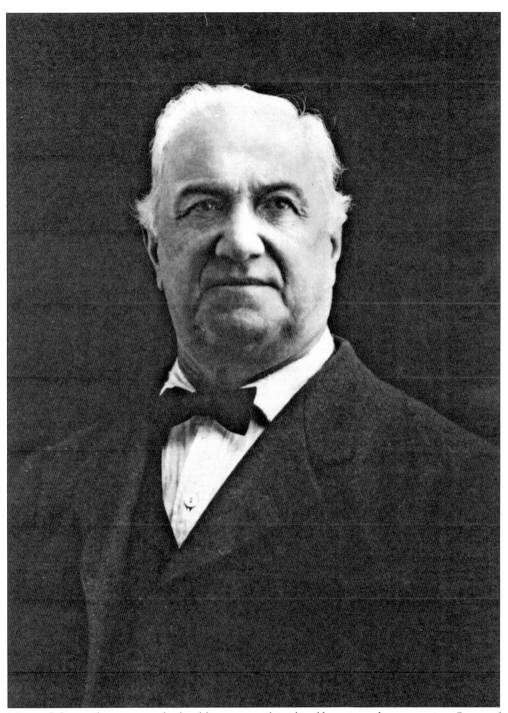

Many of those who came to find gold wore a multitude of hats in order to survive. Some of them grew vineyards, made wine, and became public servants, like Giovanni Rocca, who came from Italy in 1857. He owned large vineyards near Jamestown and became a Tuolumne County supervisor. He is the great-great-grandfather of Ron Gianelli, who still operates a winery on the family property. (Courtesy of Gianelli Vineyards.)

Grapevines and pear orchards grew on the same property owned by Dr. Thomas Milton Todd in Todd's Valley. Todd settled in the valley in the early 1950s. These photographs were taken in 1951 at a time when pears had replaced many of the vineyards that had been planted years earlier. The effects of Prohibition and the phylloxera present in California, including Placer and El Dorado Counties since the 1800s, are credited with wiping out the vineyards, making it necessary for farmers to replace the acreage where vineyards were planted with pear orchards in order to survive. (Both, courtesy of Placer County Museums)

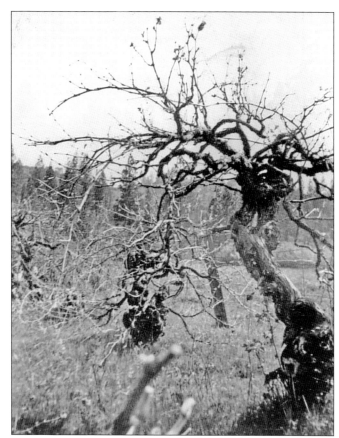

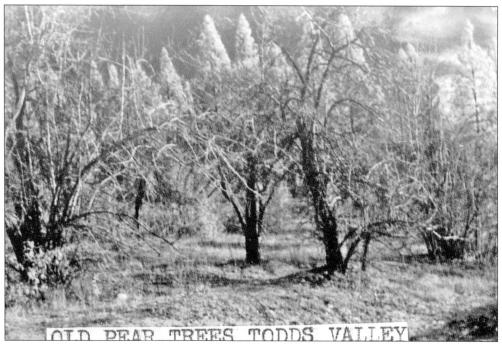

OLD PEAR TREES TODDS VALLEY

Many wineries sprang up around the Gold Country as compliments to other endeavors. In 1851, the Bernhard family opened a traveler's rest hotel in Auburn, and in 1874, they built this winery on the premises. In 1973, the property was given to Placer County, and a museum is now housed in the Victorian house where the Bernards used to reside. (Courtesy of Placer County Museums.)

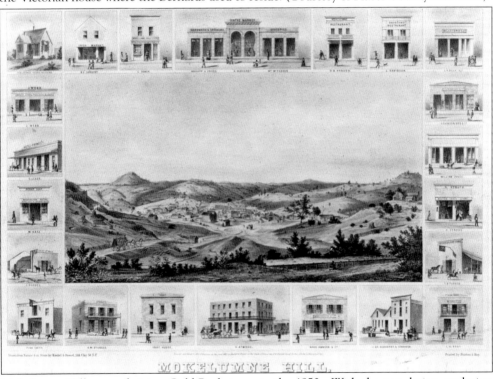

Mokelumne Hill was a thriving Gold Rush town in the 1850s. With the population explosion in the California foothills caused by gold seekers, the town grew to be the largest in Calaveras County, which at the time encompassed what is now Amador County. The town, with its rolling hills, became an area rich in wine production. (Courtesy of Calaveras County Archives.)

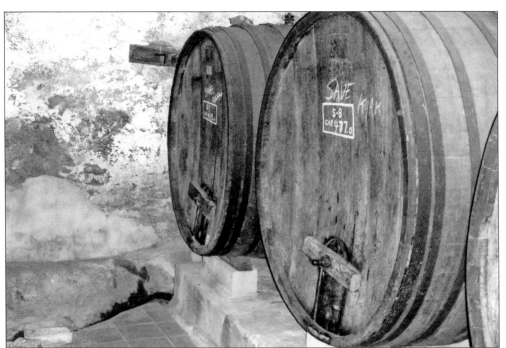

Large wine barrels from the late 1800s still stand in the cellar underneath the former D'Agostini home at the winery. Basements and cellars underneath houses were used to store wine because they were cool and dry. Often a foot or more of straw was placed between the first floor of the house and the cellar to provide insulation and maintain a constant temperature below. (Both, courtesy of the Sobon family.)

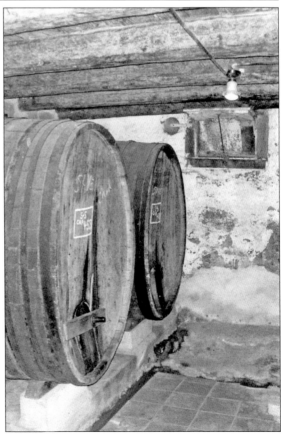

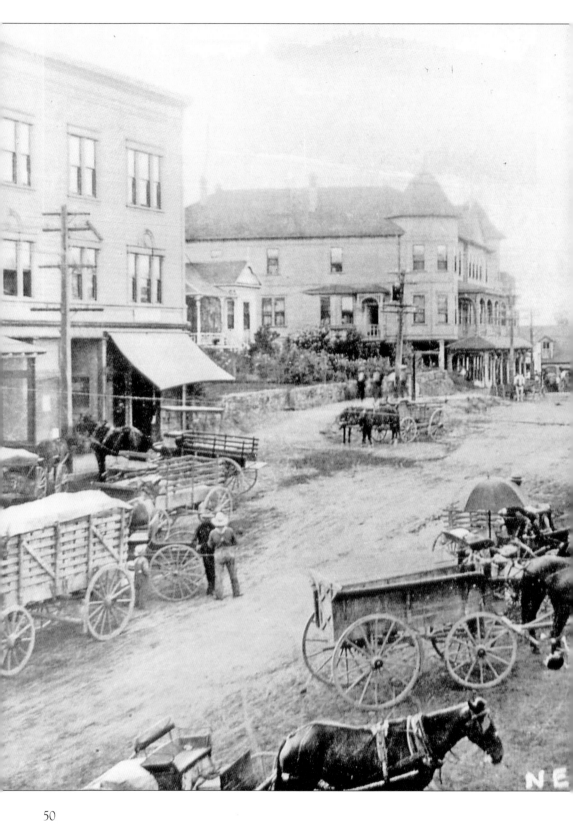

CASTLE CAL.

As it became more and more difficult to ply a yield from the gold fields, the foothills region became more agricultural. Railroads ran through the northern part of the area, making it easier for farmers and ranchers to ship their goods. In this 1910 image, many fruit stands set up shop in Newcastle. Behind the building to the right are train tracks, and the building to the left with the turrets is a hotel called the Pomona. (Courtesy of Placer County Museums.)

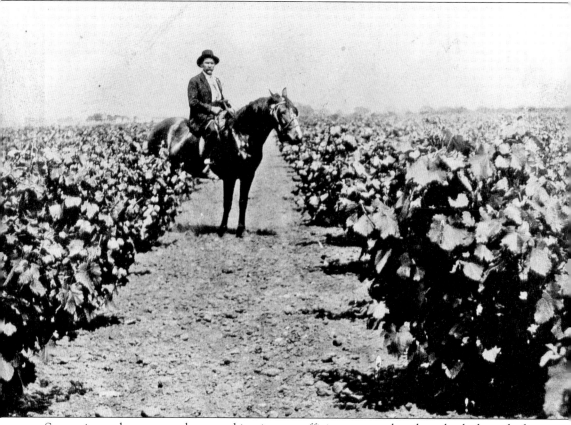

Some vineyards were very large, making it more efficient to travel on horseback through the vineyards to check the fruit and the vines. Originally from Italy, Louise Bianco settled in Roseville, and his vineyards stretch as far as the eye can see in this c. 1900 image. (Courtesy of Placer County Museums.)

Two

DORMANCY

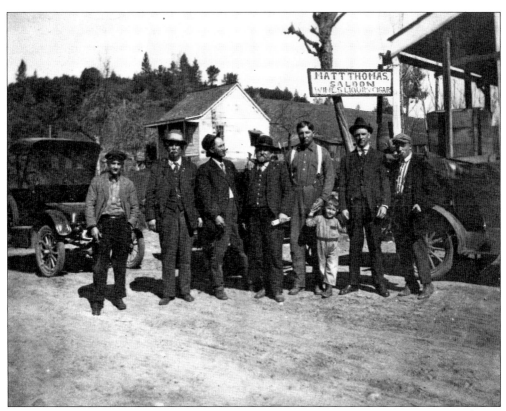

This group stands in front of the Matt Thomas Saloon at Scottsville Station, where a thirsty traveler could stop on his ride through Amador County. This c. 1909 photograph was taken before Prohibition went into effect and selling alcohol with a content of over 2.75 percent was made illegal. Notice that the saloon makes a point of advertising that it sells not only "liqurs" [sic] but wines as well. (Courtesy of Amador County Archives.)

J.C. Mazal had extensive orchards and a winery and entered the fruit of his farm into competitions far and wide. In the early 1900s, much of his fruit consisted of Salway peaches, along with Tokay and Black Prince grapes. In 1904, he entered his produce into the Louisiana Purchase Exposition, also known as the St. Louis World's Fair, and won bronze medals for grapes and dates. (Courtesy of Placer County Museums.)

Although the area had experienced a decline in population after the Gold Rush, becoming an agriculturally based economy, vineyards and their fruit could still be a lucrative business. Here, old vines that could have taken root at the beginning of the 1900s still grow in the Shenandoah Valley. (Photograph by Larry Angier.)

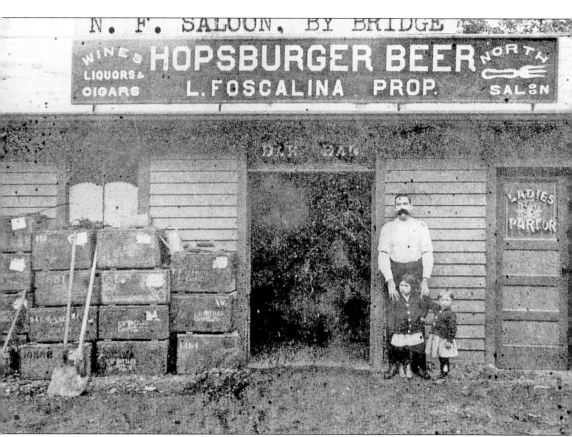

Letting customers know what merchants sold and where they were located could sometimes be achieved with a creative name. Here, the North Fork American River Saloon, owned by L. Foscalina, achieved both. He sold wine, beer, and cigars and was located by the old Highway 49 bridge that ran over the North Fork of the American River. Note the drawing of a fork on the sign. (Courtesy of Placer County Museums.)

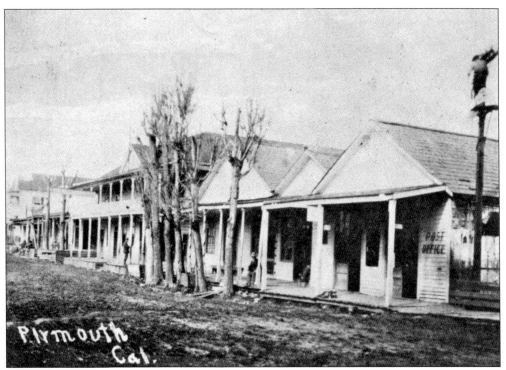

This photograph of Plymouth was taken just as the temperance movement was gaining steam. In an apparent attempt to counteract the movement, the April 10, 1909, issue of the *Pacific Rural Press* wrote, "The production of pure light wines for home consumption should be encouraged, as conducive to temperance. France and Italy are comparatively free from alcoholic excess, and it is not wines nor light beers that 'make night hideous' in the booze towns of California." (Courtesy of Amador County Archives.)

There were by some accounts hundreds of wineries producing wine until the Volstead Act was enacted, beginning the era of Prohibition. Like many others, the Vogliotti Ranch near Murphys made and sold wine until the end of Prohibition in 1933, when expensive licensing requirements overseen by the newly minted Alcohol Tax Unit of the Bureau of Internal Revenue made it cost-prohibitive to continue commercially producing wine. (Courtesy of Calaveras County Archives.)

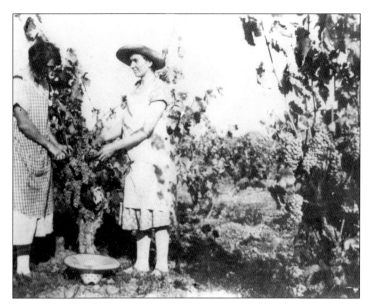

Everyone pitches in during harvest. Here, two women from the Gianelli family help with the grape harvest in the early 1900s. Although the most notable vine in the region, the Zinfandel, is thought to have been the one most planted, Ron Gianelli believes from talking with old-timers that many vines were called Zinfandel but were actually other Italian varietals that did well in the region. (Courtesy of Gianelli Vineyards.)

Cork wine-bottle stoppers are made from cork oak trees in a sustainable way, with the outer bark being stripped of the trees every 9 to 12 years. Some of the trees live up to 200 hundred years. In 1951, a cork oak tree from Spain was photographed in Todd's Valley. Its bark could have been used by D. Todd to cork local wines. (Courtesy of Placer County Museums.)

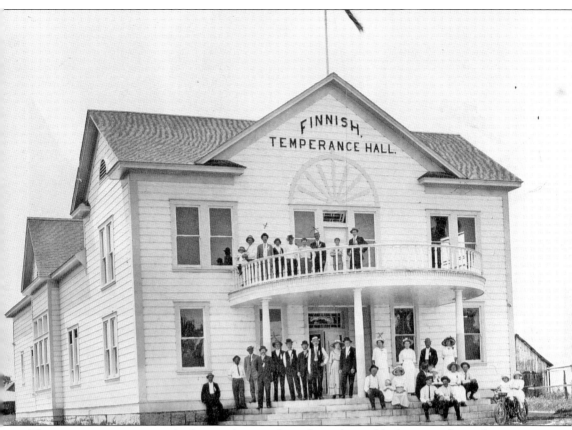

The temperance movement had many chapters throughout the world advocating for moderation and/or complete abstinence from alcohol. It, along with other societal factors of the day, helped to pass the 18th Amendment, commonly known as Prohibition. In 1912, members pose for a photograph at the Finnish Temperance Hall in Rocklin. The hall was built in 1905. (Courtesy of Placer County Museums.)

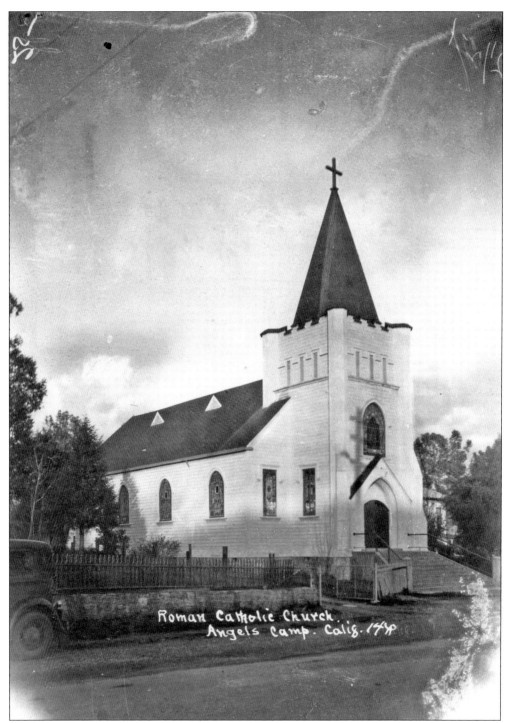

Roman Catholic Church.
Angels Camp. Calif. 1490

One provision in the Volstead Act, more commonly known as the National Prohibition Act of 1919, which was enacted in 1920, allowed wineries to make small quantities of wine for use in the sacrament of communion. The Angels Camp Catholic Church was part of the Sacramento Diocese of the Roman Catholic Church. (Courtesy of Calaveras County Archives.)

Although Prohibition had just been enacted, the contributions of viticulturist and public servant Anthony Caminetti were recognized in 1922 when Caminetti Memorial Hall at the Preston School of Industry was dedicated to him. The plaque on the building was donated by local women's clubs. Caminetti was instrumental in creating the groundbreaking school and the hope that it would reform juvenile offenders through structure, education, and hard work. (Courtesy of Amador County Archives.)

Like other viticulturists and winemakers in the area, Anthony Caminetti wore a multitude of hats. He was not only a driving force and supporter of viticulture, but as a state senator he was also instrumental in bringing the new wave of juvenile justice reform to the area in the form of the Preston School of Industry in Ione. (Courtesy of Amador County Archives.)

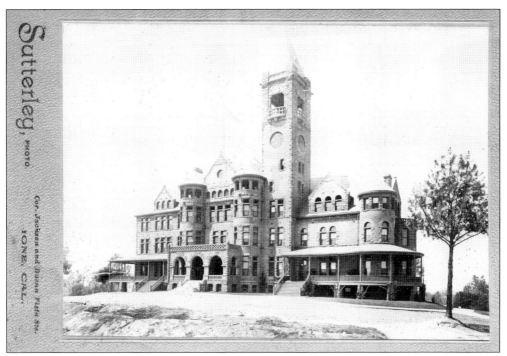

Legislation creating the Preston School of Industry in Ione (now known as Preston Castle) and its counterpart, the Whittier State Reformatory for Boys and Girls, was signed in 1889. The cornerstone for the Preston School of Industry was laid on December 23, 1890, and brought with it a new hope of reforming juvenile offenders by teaching them life skills. (Courtesy of Amador County Archives.)

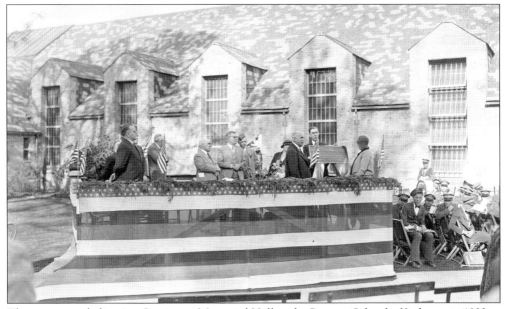

The ceremony dedicating Caminetti Memorial Hall at the Preston School of Industry in 1922 to public servant and viticulturist Anthony Caminetti was attended by dignitaries and came with much fanfare. (Courtesy of Amador County Archives.)

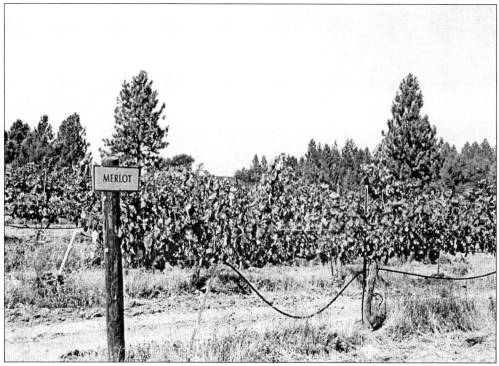

Here, a vineyard of Merlot grapes is one of many different varietals of vineyards growing in the Gold Country. Although vineyards and winemaking would dwindle after Prohibition, they illustrate the importance of agriculture in the foothills after the rush for gold was over. (Courtesy of Amador County Archives.)

Placerville, Cal.,————————*191*—

M———————————————————

то **JOHN A. FOSSATI** DR.

DEALER IN AND MANUFACTURER OF

WINES AND BRANDIES

WINERY TELEPHONE, LOCAL 534 RESIDENCE TELEPHONE, FARMERS 851

John A. Fossati learned winemaking from his grandfather Giovanni Lombardo, who was a vineyard and winemaking pioneer near Placerville. John, the son of Giovanni's only child, Sarah, eventually continued on in the family business, as this order form shows. He expanded the business, opening up a second winemaking facility, and continued to make wine until Prohibition. (Courtesy of the Boeger family.)

Enrico and Carline Fannelli D'Agostini pose for a portrait with their two eldest children, Amelia (standing) and Michele, in 1917, six years after Enrico bought the Uhlinger Winery with Italian partners Fioravanti and Gualtieri. Caroline is pregnant with their third child, Tulio. (Courtesy of Armenio and Mary Lou D'Agostini.)

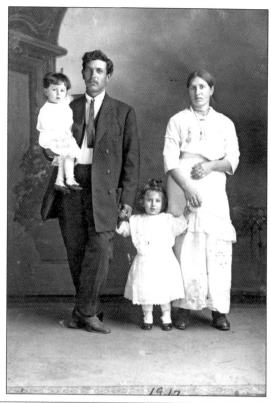

Zinfandel vines can be seen terraced on the hillside behind the D'Agostini Winery. By 1920, Enrico D'Agostini had bought out his partners and was the sole owner of the winery, which he would eventually pass down to his sons. This photograph from the early 1930s shows the home, winery, and vineyards. (Courtesy of Armenio and Mary Lou D'Agostini.)

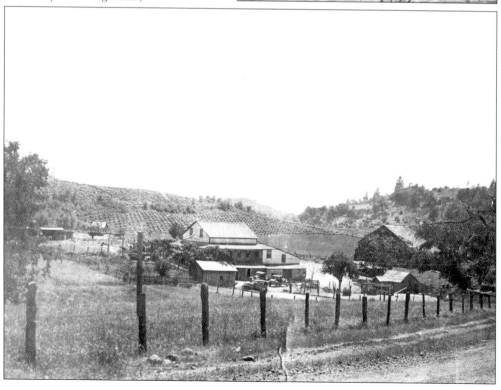

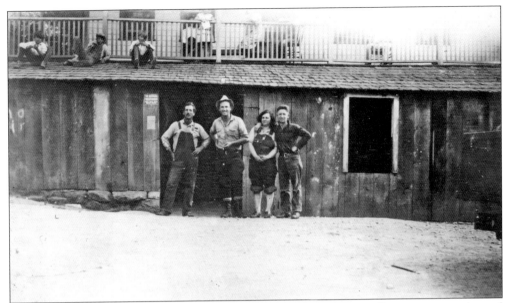

Many winery families used the bottom level of their homes as a wine cellar, as it was cooler and held a constant temperature throughout the year. The children of Enrico and Fannelli line the roof and porch of the house in this photograph from the 1920s. Enrico stands to the far left, and next to him is Clarence Flick, owner of Omo Ranch. The house can still be seen at Shenandoah Estate in the Shenandoah Valley. (Courtesy of Armenio and Mary Lou D'Agostini.)

RETAILER'S PRICES			D'AGOSTINI WINERY		Rt. 2, Box 19 Ph. (209) 245-6612	
Effective Feb. 1, 1982			Plymouth, California 95669			
ZINFANDEL		CASE	BURGUNDY RESERVE			CASE
(Estate Bottled)			CLARET	1.5 L		12.30
	¾ L	31.20		¾ L		15.30
	⅜ L	33.60		⅜ L		17.50
DRY MUSCAT			SAUTERNE			
	1.5 L	13.10		1.5 L		12.70
	¾ L	16.95		¾ L		15.85
	⅜ L	19.50		⅜ L		18.00
QUANTITY DISCOUNT 1 - 9 Cases Net , 10-24 Cases 3% 25 or more Cases 5%						

Price sheets are given to prospective wine buyers. Here, Amador County's best-known wine, Zinfandel, is shown in a prominent place on the D'Agostini Winery price sheet. (Courtesy of the Sobon family.)

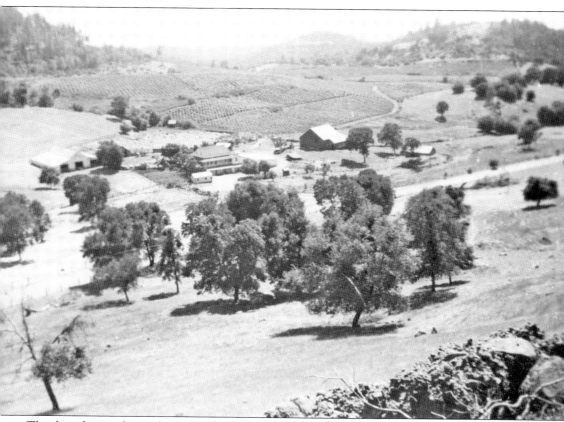

This broad view shows the extent of the D'Agostini Winery holdings in the 1950s. Enrico D'Agostini first came to the area in 1908, working in the copper mines of Copperopolis. Like other immigrants at the time, he returned to Italy to get married and was drafted into the army. He returned to the Gold Country with his wife, Fannelli, and purchased the winery with its 125 acres from Uhlinger. He planted an additional 90 acres, primarily with Zinfandel but also included Golden Chasselas, Carignane, Mission, Muscat Canelli, and Alicante Bouschet. The winery holds the distinction of being the only one in the area to continuously operate through Prohibition to the present day and is now owned by Leon and Shirley Sobon. (Courtesy of Armenio and Mary Lou D'Agostini.)

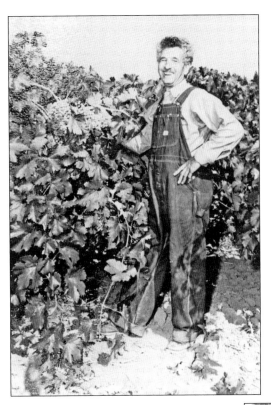

Enrico D'Agostini stands with grapevines. He purchased the Uhlinger Winery and its 125 acres in 1911 with two partners, but by 1920 he became the sole owner, and he passed on the business to his sons. (Courtesy of the Sobon family.)

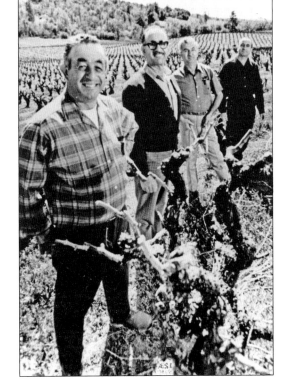

The sons in Enrico D'Agostini & Sons Winery, from left to right Michele, Tulio, Armenio, and Henry D'Agostini, stand in the vineyard in this 1960 photograph taken by the *Sacramento Bee*. (Courtesy of the Sobon family.)

Farmers are often resourceful in taking care of their crops. Following World War II, the D'Agostini brothers decide to give a jeep a try, instead of a donkey, to pull the plow in the vineyard. (Courtesy of the Sobon family.)

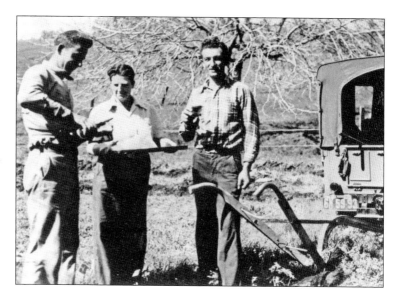

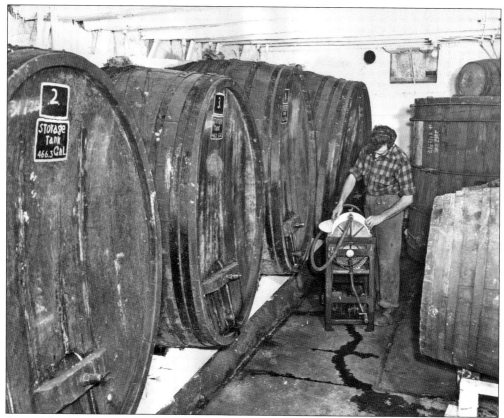

One of the D'Agostini brothers (possibly Tulio) filters one of the winery's 19th-century casks. Wine is filtered towards the end of the maturation time to clarify it, removing any cloudiness or solid matter in the wine and stabilizing it to remove any yeast, bacteria, or other microscopic organisms that may cause the wine to spoil after it is bottled. (Courtesy of Kay D'Agostini.)

Everyone needs to take a break now and then. Here, Armenio D'Agostini (left) and Altero D'Agostini (center) take a break from working the vineyard with a Fiddletown rancher named Mr. Green with a cool sip of beer, not wine. After World War II, the men are using a surplus military jeep to plow the field instead of the traditional donkey. (Courtesy of the Sobon family.)

Part of the wine business is making sure that customers receive the wine far and wide. The D'Agostini family delivered wine as far as Santa Cruz and San Francisco. Here, Tulio D'Agostini gets ready to deliver wine to customers. The side of the truck reads in part, "Enrico D'Agostini & Sons, Bonded Winery." Note the four-digit telephone number. (Courtesy of Kay D'Agostini.)

Ken Deaver Sr.'s stepfather, Jack Davis, works the fields during harvest in 1931. Jack inherited vineyards his father, John Davis, planted during the Gold Rush. Jack not only tended the Mission vines, he also had cattle, sheep, and pigs, along with orchards of walnuts, apricots, and more. (Courtesy of Deaver Vineyards.)

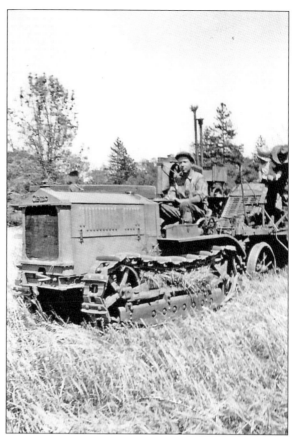

The most well-recognized wine in Amador County is the Zinfandel, which by the early 1980s accounted for 75 percent of 1,600 vineyard acres in that area. Napa County wineries, like Sutter Home, owned by the Trinchero Family Estate, bought the local varietal, bottling it as an Amador County Zinfandel. Here, Kenneth Deaver Sr. tends to his vineyard in 1960. According to family stories, his grandfather John James Davis planted Zinfandel on advice from Adam Uhlinger in the 1870s. (Courtesy of Deaver Vineyards.)

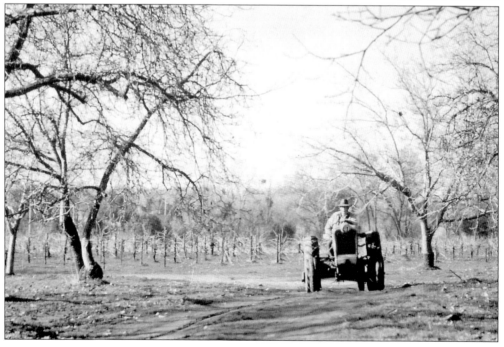

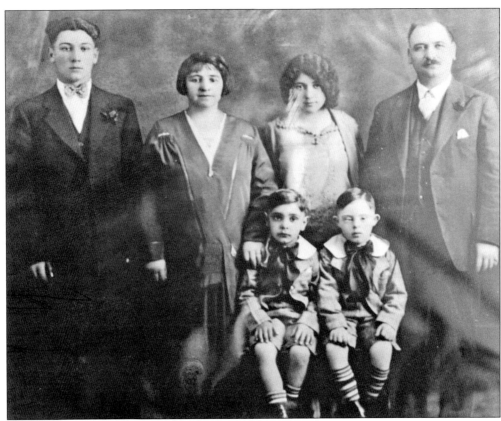

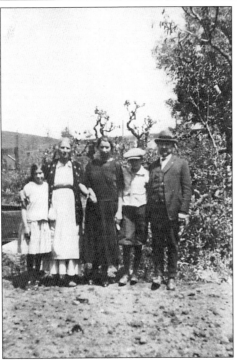

When researching families of the Gold Rush era, it is amazing how close some of them lived in their homelands, only meeting when they came to find their fortunes in California. Ron Gianelli's mother and father, Tillia Gatti and Nino Gianelli, lived near each other in the Italian area of Liguria and never met. "They lived up and down a hill from each other," Ron said. Nino followed his father to the United States in 1920 with his mother after the family saved up enough to bring them over; Tillia came over in 1924. The two did not meet until they were grown, when both of them visited Tillia's aunts in Jamestown at the same time. Above, Nino (far left) and his family pose for a portrait in Italy. At left, from left to right, Tillia Gatti, Margarte Gianelli Rocca (her great-grandmother), an aunt, Vitoro Gatti, and presumably Giovanni Rocca stand in the Jamestown vineyard in the early 1900s. (Both, courtesy of Gianelli Vineyards.)

ENRICO D'AGOSTINI & SONS

B. W. No. 2459 14th Permissive Dist.

PLYMOUTH, CALIFORNIA

PACKED
AND
SHIPPED TAX PAID BY

Date
Shipment..................................... 195....

Shipment No.................................

Serial No.

CONSIGNEE OR VENDEE

Name..

Address...

CALIFORNIA

DRY MUSCAT

Alcohol 13% by Volume

This shipping tag for California Dry Muscat is from the Enrico D'Agostini & Sons winery, the only winery in the Mother Lode that has continually operated from its beginnings during the Gold Rush through Prohibition to today. (Courtesy of the Sobon family.)

Phone 245-6612

D'Agostini WINERY

Plymouth, Calif.,_____19____

M_____

Licensee_____ ACCOUNT FORWARD

1
2
3
4
5
6
7
8
9
10
11
12
13
14
15

28

In today's era of computer-generated receipts, this carbon-copy purchase receipt from the D'Agostini Winery is a reminder of a bygone time. (Courtesy of the Sobon family.)

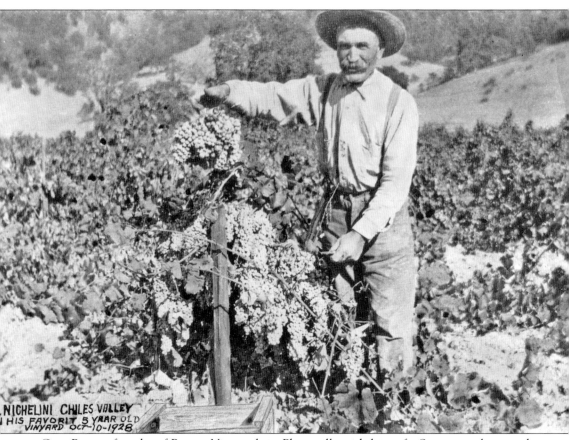

NICHELINI CHILES VALLEY
HIS FAVORIT 5 YEAR OLD
VINYARD OCT-10-1928

Greg Boeger, founder of Boeger Vineyards in Placerville with his wife, Susan, was born with agriculture in his blood. His father's family raised crops like apricots, while his mother's father, Anton Nichelini, founded a winery in Napa that is the oldest continuously operated family-owned winery in California. Here, Anton stands in his vineyard in Chiles Valley in 1928. (Courtesy of the Boeger family.)

Three

REGROWTH

Boeger
Gettin' it done since 1972.

Some wineries use their own grapes to make wine, others buy grapes, and still others use a combination of purchased and grown. Although Greg Boeger planted his first vineyard in 1973, his first crush was in 1972. He leased the only winery in the area, Gold Hill Winery, with its producing vineyards, and with this fruit he made his first wines, including Cabernet Sauvignon, Chenin Blanc, and Riesling, among others. (Courtesy of the Boeger family.)

In the 1850s, Italian immigrants flocked to California's Sierra Nevada to search for gold. After the mines ran dry, many of these red wine–loving prospectors became grape growers, fueling a vibrant frontier wine industry. A century later, Montevina, the Sierras' flagship winery, began cultivating classic Italian grape varieties in its Amador County vineyard. Given Amador's similarity in terrain and climate to Italy's finest wine regions, this marriage of old and new world viticulture has borne beautiful fruit, indeed. Montevina's Terra d'Oro (Land of Gold) Zinfandel, our reserve bottling, offers intense aromas of ripe raspberries, licorice and vanilla, with rich, silky, spiced-berry flavors. It beautifully complements a wide range of Italian-style cuisines.

TERRA D'ORO MONTEVINA ZINFANDEL

Established in 1970, Montevina was founded by Walter Field and his winemaker son-in-law Cary Gott, who released their first vintage in 1973. At that time, they primarily produced Zinfandel, Cabernet Sauvignon, and White Zinfandel. The winery was purchased by the Napa Valley–based Trinchero Family Estates in 1988 and has grown to produce 200,000 cases of wine annually. In 2009, the winery's name changed to Terra D'Oro. (Courtesy of Terra D'Oro/Montevina Winery.)

ESTATE 1974 GROWN

Montevina

Shenandoah Valley

English Walnuts

Franquette • Mayette
Eureka • Hartley

GROWN & PACKAGED BY
MONTEVIÑA
Plymouth, Amador County, California

NOT LESS THAN 5 lbs.

Walnut Cake

3 cups walnut meats chopped very fine until almost a powder

4 eggs separated

1 ⅛ cups sugar

grated rind of one lemon

Grease with butter and dust with flour a deep 9-inch pan.

Beat egg yolks and sugar until light and fluffy.

Beat egg whites until stiff, add small amount to the egg yolks to loosen it. Beat walnuts into three egg yolks and when well blended fold in the rest of the egg whites. Pour into the pan and cook for ¾ to one hour in a 375° oven or until the top is golden brown.

Dust with powdered sugar. It will keep moist for days.

Walter's Roasted Walnuts

Place whole nuts in 350° oven for 20 minutes or more if desired. The best way to eat walnuts! Try the cake with these also.

The vineyards in the Mother Lode were often part of larger ranching endeavors that included farming crops, such as walnuts and apples, and raising animals, such as pigs, sheep, and cattle. Walter Field of Montevina not only sold wine but also English walnuts from his pickup truck and gave buyers this recipe for walnut cake. (Courtesy of Terra D'Oro/Montevina Winery.)

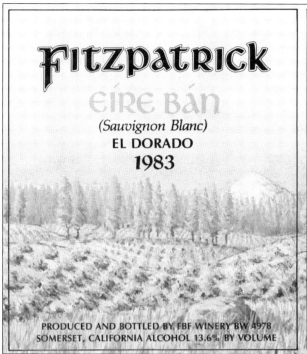

1983 Eíre Bán
Sauvignon Blanc: 80%
Chenin Blanc: 20%
This wine will delight the Irish and non-Irish alike. It is dry and medium-bodied with lively fruit flavors. The perfect wine for all occasions!

Bill Bethun
WINEMAKER

Fitzpatrick
Eíre Bán
(Sauvignon Blanc)
EL DORADO
1983

PRODUCED AND BOTTLED BY FBF WINERY BW 4978
SOMERSET, CALIFORNIA ALCOHOL 13.6% BY VOLUME

The Sierra foothills region, with its varying terrains, is not always an easy place to plant vineyards. It is heavily forested in areas, making it necessary to clear the land before planting can begin. Brian Fitzpatrick cleared a heavily forested area to make way for the planting of his second vineyard in Fairplay. This label illustrates the forested lands that surround the vineyard. (Courtesy of Fitzpatrick Winery.)

Jim and Pam Costello first planted vineyards for their Mount Brow Winery in Sonora to ensure the land qualified for a Williamson Act designation. The act helps keep agricultural lands in California viable by reducing property tax on the land provided that the owners comply with its strict requirements regarding building restrictions and crop production. Most vineyards are planted on land under the Williamson Act. (Courtesy of Mount Brow Winery.)

77

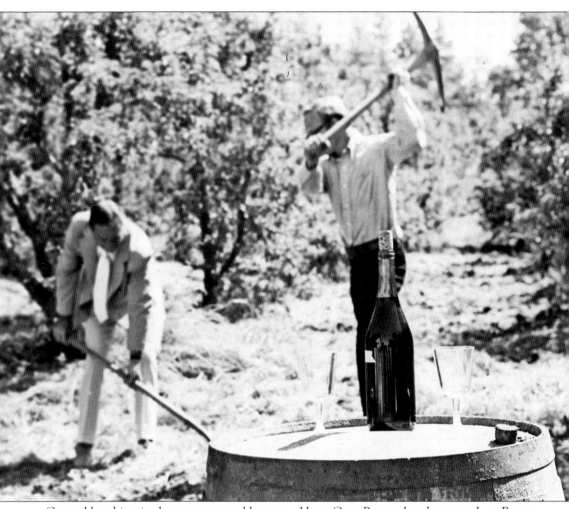

Ground-breaking is always a memorable event. Here, Greg Boeger breaks ground on Boeger Winery in 1972 alongside local dignitaries with family and friends in attendance (next page). Greg was the frontrunner of the wine renaissance in the northern Gold Country region of El Dorado. From an agricultural family, he received a master's of science in agricultural economics and a minor in viticulture at UC-Davis. Encouraged by a 1967 *Sacramento Bee* article about experimental vineyards in the area, he looked into buying property for a winery. (Courtesy of the Boeger family.)

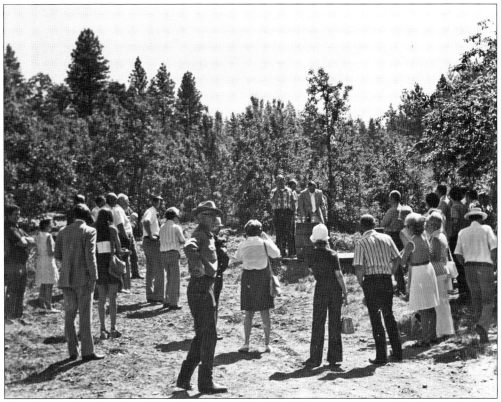

Greg Boeger found and purchased the historic Lombardo-Fossati property when he was looking to start a winery. One of the forerunners of the wine renaissance in the northern Gold Country, he has grown the family winery's production from 500 cases in 1972 to 20,000 cases in 2012. Boeger wines can be found all over the United States, in European countries, and soon in China. (Courtesy of the Boeger family.)

Susan Boeger's family looks on at the opening ceremonies for Greg and Susan's Boeger Winery in 1972. The two were pioneers in the wine renaissance in the northern Gold Country. (Courtesy of the Boeger family.)

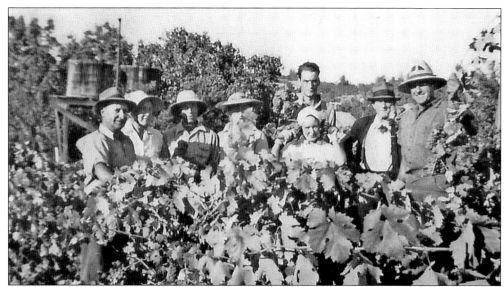

In 1968, Napa Valley growers were charging $200 a ton for Cabernet grapes. This cost led Louis "Bob" Trinchero to look elsewhere to buy grapes for his wines. Introduced to Amador County Zinfandel by wine merchant Darrell Corti, Trinchero bought his first grapes in the area from Ken Deaver Sr. He offered Deaver Sr. $60 a ton, and Deaver Sr. countered with $65. After they shared a bottle of Deaver's homemade wine, Trinchero ended up paying $115 a ton. Here, Kenneth Deaver Sr. (tallest in back) stands in a vineyard with friends. (Courtesy of Deaver Vineyards.)

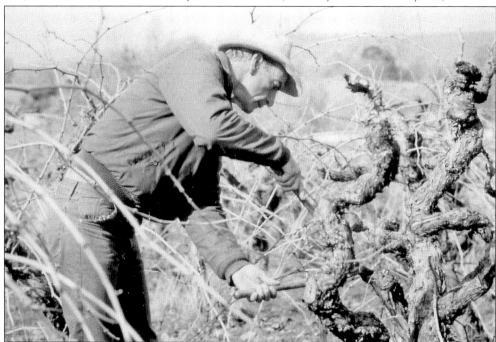

Kenneth Deaver Sr. cultivated Zinfandel and Mission vines for selling and Muscat at the edges of the vineyard because deer like Muscat and would eat the fruit off those vines, leaving the vines in the middle of the vineyard alone. This effectively protected the Zinfandel and Mission vineyards without having to build a fence to keep the deer out. (Courtesy of Deaver Vineyards.)

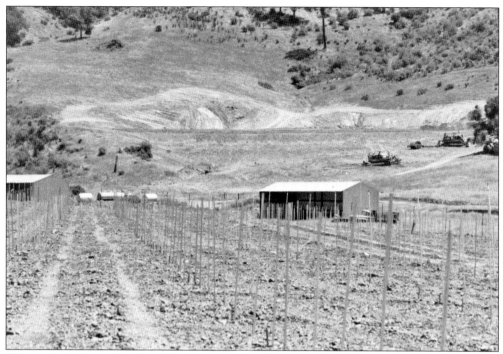

"Grapes don't like wet feet," said Eric Costa, an Amador County historian and winemaker. Although wine grapes do not take a lot of water, reservoirs often need to be built in the dry foothills to bring the water they do need. Wineries often build their own reservoirs to make sure crops are sufficiently irrigated. One can see the man-made water source built by Chatom Vineyards to water its crops in the Esmeralda Valley. (Courtesy of Chatom Vineyards.)

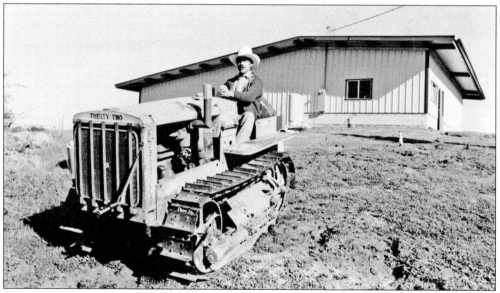

The new wave of winery entrepreneurs brought with it people from a variety of backgrounds, from scientists to government workers to those who had grown up in agriculture. Ben Zeitman of Amador Foothill Winery, pictured driving a tractor, said he had never planted a vine before buying acreage in the Shenandoah Valley and starting a winery. (Courtesy of Amador Foothill Winery.)

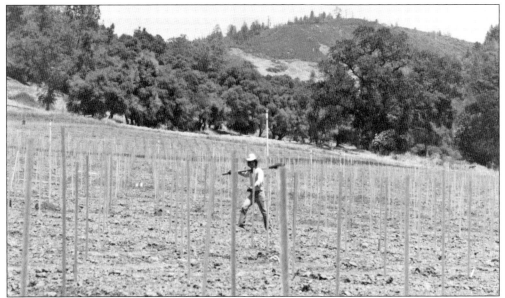

Many of the wineries of the 1970s wine renaissance in the Gold Country planted their own vineyards on land where cattle had previously grazed and other crops, like hay, had been grown. In 1981, phase 1 of Chatom Vineyards was planted in the Esmeralda Valley at the old Higgins Ranch, where a mixture of Chardonnay and Chenin Blanc grapes were planted. (Courtesy of Chatom Vineyards.)

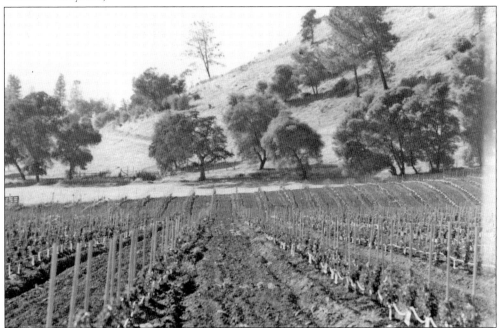

As the Gold Country began to once again take shape as a wine region, there was a spirit of community among the wineries, and they shared their knowledge with one another. Gay Callen, founder and owner of Chatom Vineyards, called on Frank Alviso of Clockspring Vineyards and Leon Sobon of Sobon Estates, both located in the Shenandoah Valley, to share their knowledge with her before she planted her first vineyard. (Courtesy of Chatom Vineyards.)

The Sierra foothills region is home to many different agricultural endeavors. Although wine grapes are increasingly taking a larger role in the agricultural output in the region, cattle still holds a large share of the agricultural output. Here, cattle watch as Chatom Vineyards plants its first vineyard in the Esmeralda Valley. Before the grapes were planted, hay was grown on the land. (Courtesy of Chatom Vineyards.)

FBF Winery is a small winery located in southern El Dorado County, owned and operated by the Bertram and Fitzpatrick families. We offer a limited production of fine varietal wines from select vineyards of the Sierra Foothills.

To visit our winery, call 916/626-1988 or 209/245-3248 for an appointment.

FITZPATRICK
TEHEMA COUNTY
Cabernet Sauvignon
Mt. Lassen Vineyards
1981

PRODUCED AND BOTTLED BY FBF WINERY BW #578
SOMERSET, CALIFORNIA ALCOHOL 12.6% BY VOLUME

1981 Mt. Lassen
Cabernet Sauvignon

The grapes came from the foothills of Mt. Lassen. They were picked on 9-22-81, at an average of 22.0° Brix. The wine was aged in small oak cooperage, and lightly filtered prior to bottling. This is a Cabernet built to last, with plenty of fruit, good acidity, and ample tannins.

Bill Bertram
WINEMAKER

There are many ways to care for vineyards, with many wineries using sustainable practices to grow their vines. Since Brian and Diana Fitzpatrick started farming in Fair Play in 1974, they have been certified organic in their planting methods. Because of increased government regulations through the years, this designation has become increasingly more difficult and costly to obtain. (Courtesy of Fitzpatrick Winery.)

Grapes have to be harvested at just the right time, when the sugars (Brix) are at the correct level for a particular varietal. When the fruit begins to ripen, winemakers are out in the vineyards checking the Brix and pH levels and tasting the entire fruit, including the seeds, to figure out when the fruit is at its best and needs to be harvested. Here, Ron Gianelli (right) leads a crew of harvesters at his vineyards in Jamestown. (Courtesy of Gianelli Vineyards.)

Very rarely are machines used to pick grapes at harvest time in the Mother Lode, because the rolling terrain makes it very difficult to harvest mechanically. This need for manual labor slows down the harvest process and drives up the cost of gathering grapes in the region. This in turn drives up the cost of harvesting when compared to other parts of the state such as the Central Valley and the Napa/Sonoma wine regions. (Courtesy of Mount Brow Winery.)

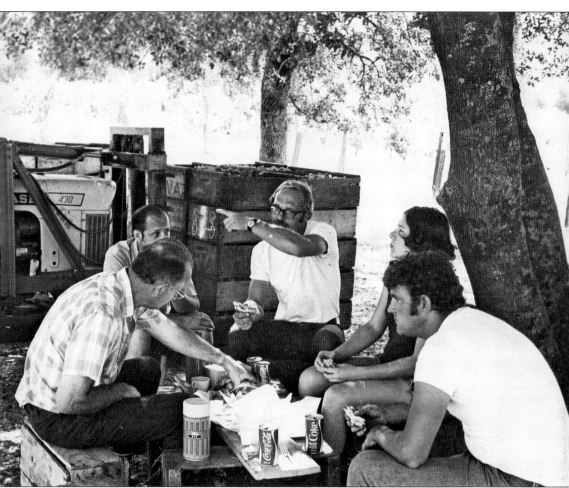

During Prohibition, most of the vineyards in El Dorado County were pulled up and replaced by pear orchards. When Greg Boeger (center) bought the historic Lombardo-Fossati property, he planted 10 acres that included Merlot, Zinfandel, and Cabernet Sauvignon. Through the years, he has converted the pear orchards to vineyards, leaving only one pear orchard on the property across from the historic Lombardo-Fossetti house. Here, in the early 1970s, he and his crew rest during a harvest. (Courtesy of the Boeger family.)

ESTATE 1974 BOTTLED

Monteviña

Shenandoah Valley, California

Sauvignon Blanc

Grown, Produced & Bottled by Monteviña Wines
Plymouth, Amador County, California

ALCOHOL 12½% BY VOLUME

Early in the resurgence of this winemaking region in the 1970s, several new varietals were favorites to be planted. Along with the well-known Zinfandel, other varietals were being planted early on, including Sauvignon Blanc, Barbera, Merlot, Cabernet Sauvignon, White Riesling, Chardonnay, Chenin Blanc, and Petite Syrah. This is a label from a 1974 Montevina Sauvignon Blanc. (Courtesy of Terra D'Oro/Montevina Winery.)

With years of experience under their belts, it is not uncommon for winemakers to eventually open their own wineries. Steve Millier, the original winemaker for Stevenot Winery in Murphys, did just that with his wife, Liz, when they opened Milliaire Winery in 1983. They bought Black Sheep Winery (started in 1984) when its original owners, David and Janis Olson, retired. Now, he makes wine for his own labels as well as Ironstone Vineyards. (Author's collection.)

The soil in the Mother Lode area is comparable to that in the wine regions of Italy. Ron Gianelli of Gianelli Vineyards had the soil tested by a laboratory in Italy, and the report came back that it mirrored that of Tuscany. Gianelli's family comes from the Liguria region of Italy. His vineyards are planted in Jamestown, where his great-grandfather Giovanni Rocca planted his vineyards during the Gold Rush. (Courtesy of Gianelli Vineyards.)

With the purchase of the Montevina Winery by Trinchero Family Estates in 1988, a new era in the Shenandoah Valley began. It brought large-scale winemaking to the area. Other wineries owned by the corporation include Sutter Home, Menage à Trois, and Dona Paula. The company sells 20 million cases of its many labels worldwide. (Courtesy of Terra D'Oro/Montevina Winery.)

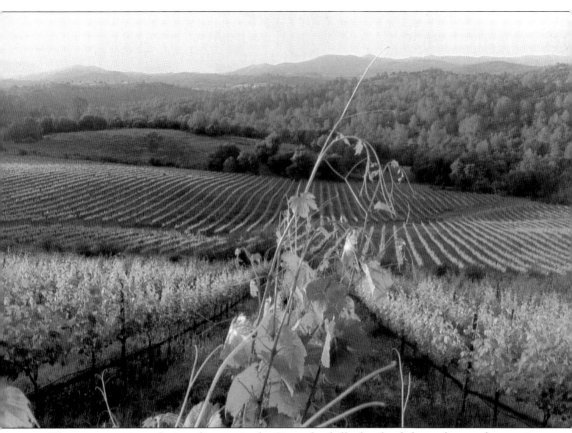

There are a variety of microclimates in the Sierra foothills that lend themselves to the growing of many grape varietals. The soil is primarily made up of decomposed granite and volcanic rock. It is very similar to the rich soil in the thriving wine region of Tuscany, Italy, producing the same rich fruit as that part of the world. (Courtesy of Gianelli Vineyards.)

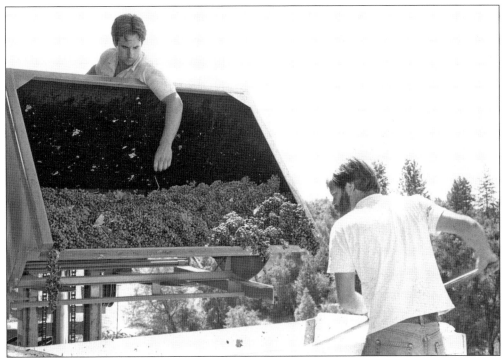

Paul Sobon (left) and Duncan, a vineyard helper, harvest grapes from the vineyard in 1987. Like many winery families in the area, members pitched in to help with harvest crush and even the planting of the vineyards. Others in the community helped out as well; when Paul was attending high school, some of his fellow teammates on the football team helped plant the family's first vineyard. (Courtesy of the Sobon family.)

Every once in a while, snow covers the lower elevations of the Sierra Nevada foothills where the vineyards grow. Here, in the 1980s, Shenandoah Vineyards are blanketed with snow. During these times, it was not unusual for Leon Sobon to cross-country ski his way around the vineyard checking the vines. (Courtesy of the Sobon family.)

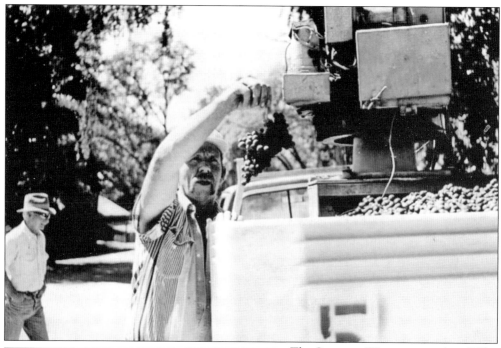

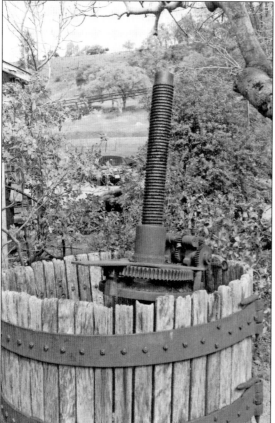

The Stevenot Winery, opened in 1978 by Barden Stevenot, is synonymous with the wine renaissance in the southern part of the region. One winery opened before Stevenot: Chispa Cellars, owned by Jim Riggs and Bob Bliss, was founded in 1976. That particular winery produced Zinfandel, Chenin Blanc, and Ruby Cabernet wines. Here, Barden Stevenot is in the background as Romi Rolleri looks at his first Tempranillo harvest. (Courtesy of Hovey Winery.)

Winemakers must wait for the grapes to be ready with just the right Brix (sugar content) and pH (acid) before they harvest the fruit. Although grapes are ready for harvest at approximately the same time of year, each varietal is harvested at a different Brix/pH level. Cooler nights in the foothills typically mean harvest is later than it is in the Central Valley. Here, an old wine press can be seen at the museum at the Sobon Estates. (Courtesy of the Sobon family.)

Every autumn, the grape crush rolls through the Gold Country, with many wives of viticulturists and winemakers becoming "crush widows" for a bit. There are many celebrations at the end of a crush, like the Big Crush Harvest Festival in Shenandoah Valley, the Murphys Grape Stomp, and Mount Brow's crush festival in Sonora, where old cars and a chance to crush grapes the old fashioned way, with one's feet, combine into a good time. (Both, courtesy of Mount Brow Winery.)

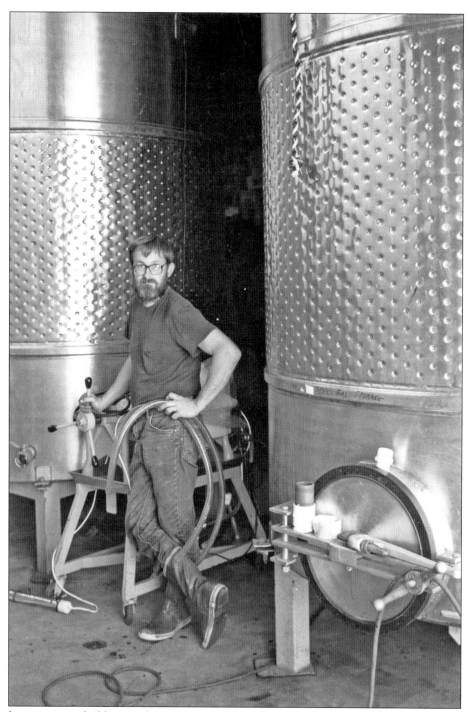

In the past, wine holding tanks were made of wood. In recent years, that has changed, and holding tanks are made of stainless steel. Like many other wineries, Shenandoah Vineyards used wooden holding tanks when the winery started in 1977 but switched to stainless steel. Here, Leon Sobon works in the winery's cellar with the ever-present stainless-steel tanks in the background. (Courtesy of the Sobon family.)

Winemakers are having fun in the 1970s. Jeff Olsen (center), founder of Black Sheep Winery in Murphys, stands with Steve Millier (left) and Chuck Hovey (right). Both Millier and Hovey came to the area as winemakers for Stevenot Winery. "The foothills have so many different climates for such a small area," said Chuck Hovey, "There's a certain intensity of flavor here. That's a quality I really like." (Courtesy of Hovey Winery.)

Winemakers often make wines for different wineries in the Gold Country. Here, Barden Stevenot (left) and Chuck Hovey stand in the Stevenot vineyards in the 1980s. Hovey came to the Murphys region of the Sierra foothills to become the assistant winemaker for Stevenot. He eventually became the winemaker and made award-winning wine for many years. Now, he makes the wine for his own award-winning Hovey Wines, which he owns with his wife, Jan, and for Gianelli Vineyards in Jamestown. (Courtesy of Hovey Winery.)

94

"We had a real supportive group of people, everyone helped everyone out," said Ben Zeitman, founder and owner of Amador Foothill Winery about the early days in the area. Zeitman came to the Shenandoah Valley from Palo Alto, where he met his Mother Lode neighbor, Leon Sobon, founder of Shenandoah Vineyards, in a home winemaking club. Sobon bought property in the area in 1978, and then sold 20 acres to Zeitman in 1980. (Courtesy of Amador Foothill Winery.)

Amador County Cellars' Ben Zietman began building his winery and tasting room in 1980. As a chemist who worked for NASA Ames before moving to the foothills, Zeitman asked a fellow NASA scientist about building a passive cooling system for his wine. The design that came out of the conversation was a cooling system built into the winery that is based on river rocks built into eight-foot-high, 50-foot-wide walls. This construction helps air passively flow through the rocks, convecting the hot air out and keeping the wine cool. (Both, courtesy of Amador Foothill Winery.)

John Kautz named Ironstone Vineyards after the iron-like rock the winery was built on. Crews had to blast out the rock to make the winery's underground caverns where wines are aged. The giant wine-cellar doors are constructed of redwood heartwood taken from wine holding tanks that were once used at the D'Agostini Winery in Shenandoah Valley. (Courtesy of the Kautz family.)

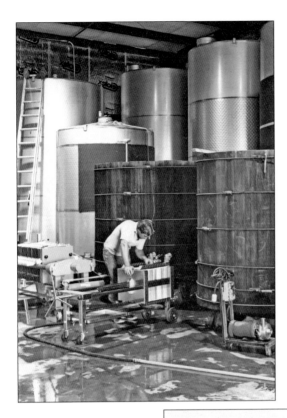

Paul Sobon filters wine in the cellars of Shenandoah Vineyards in the 1980s. (Courtesy of the Sobon family.)

Amador County is known for its Zinfandels, both red and white. Wine labels can be as distinct and enjoyable as the wines themselves. This is a simple yet elegant label for a Shenandoah Vineyards 1987 White Zinfandel. (Courtesy of the Sobon family.)

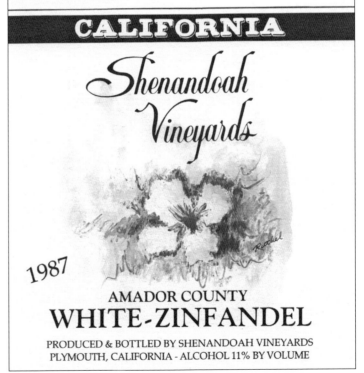

CALIFORNIA

Shenandoah Vineyards

1987

AMADOR COUNTY
WHITE-ZINFANDEL

PRODUCED & BOTTLED BY SHENANDOAH VINEYARDS
PLYMOUTH, CALIFORNIA - ALCOHOL 11% BY VOLUME

Louis "Bob" Trinchero bought Montevina in 1988 with the purpose of transforming it into an Italian winery. At the time, he planted Refosco, Aleatico, Aleanico, Barbera, Nebbiolo, and Sangiovese Grosso. His first proprietary blend at the Amador County winery was a Barbera-Zinfandel blend called Montinaro. (Courtesy of Terra D'Oro/Montevina Winery.)

Leon and Shirley Sobon purchased the historic D'Agostini Winery in 1989. Here, the couple stands next to the marker showing that the D'Agostini Winery is a California Registered Historical Landmark. (Courtesy of the Sobon family.)

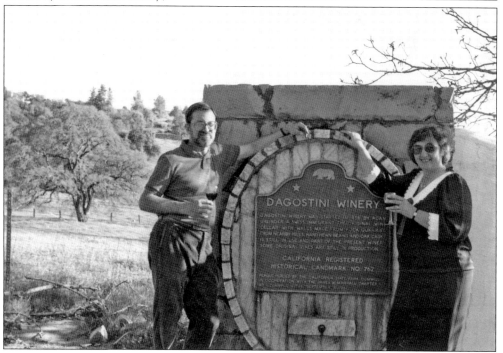

When the Sobon family bought the D'Agostini Winery in 1989, three wooden holding tanks were on the property. The tanks are made of redwood heartwood and are considered to be stronger than steel. John Kautz bought two of them from the Sobons for use at his Ironstone Vineyards winery in Murphys. Kautz used the wood to build the doors to his winery's underground cellar and line the walls of the winery's tasting room. (Courtesy of the Sobon family.)

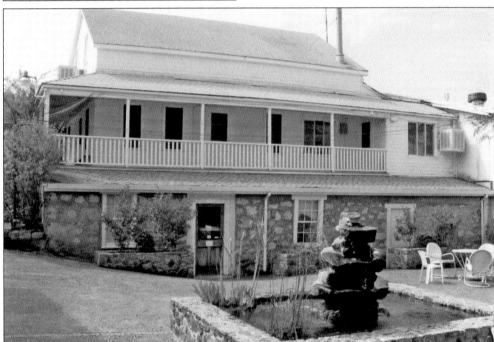

Like others who live an agricultural lifestyle, winery families often start out living on their properties with their homes near their vineyards. Here, the D'Agostini house was home to the D'Agostini family and no doubt heard the laughter and life of a large family led by Enrico and Caroline. The house can still be seen at the Shenandoah Valley Museum. (Courtesy of the Sobon family.)

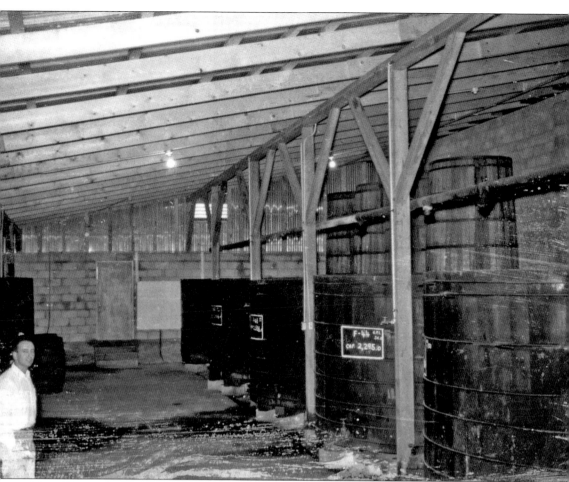

Here, D'Agostini Winery's large redwood fermentation tanks were housed in what is now the Shenandoah Valley Museum. Fermentation is the process that turns grape juice into wine. The tanks of today are commonly made of stainless steel, with many wines being barrel aged to take on the characteristics of the wood they are housed in. (Courtesy of Armenio and Mary Lou D'Agostini.)

How To Make Wine.

What you do is You take thousands of gallons of grapes, and dump them in a grape crusher.

If you don't have one, or you can't afford one, you can take off your shoes and socks. And dump the grapes into a large tank and jump up and down. The only problem is bees fly in to the tank, and you can get stung. Or you can crush them by squeezing them with your hands, but thats real slow.

Then you put the grape juice in a tank, along with the skins. Then you spread yeast over it, and in about a week wine will have formed. But during that week you have to to take something and push the skins into the grape jucie every day.

Bottling and Corking the Wine

6. After that week, you put the wine into Bottles, but get rid of the skins.
7. Then put corks in your bottles. Then its ready. You also have to have the grapes ripe.

Family-owned wineries give the next generation plenty of experience with every aspect of winemaking, from growing, harvesting, and crushing the grapes to making wine, labeling it, and selling it. Those who grew up in these families, from Ironstone Vineyards' Stephen Kautz to Boeger Wineries' Greg Boeger, all have stories to tell about being children in the fields of winemaking families. At five years of age, Jason Boeger wrote this story about the process of winemaking. He is now the winemaker at the family-owned Boeger Winery. (Courtesy of the Boeger family.)

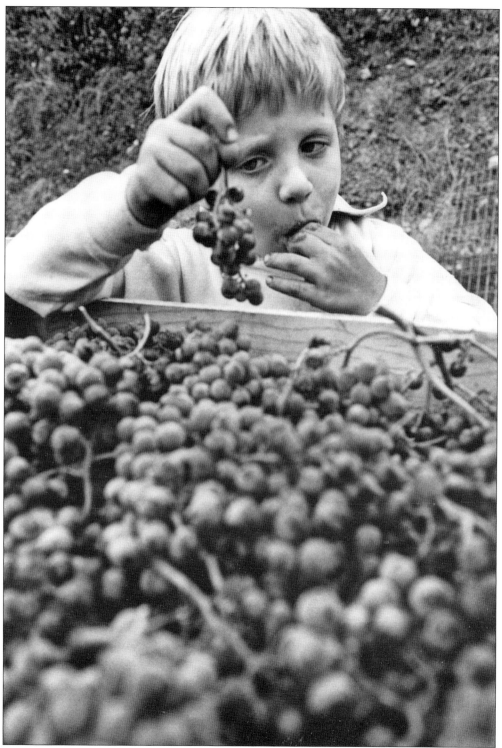

Jason Boeger, son of Boeger Winery founder Greg, tastes grapes during a harvest in the early 1970s. (Courtesy of the Boeger family.)

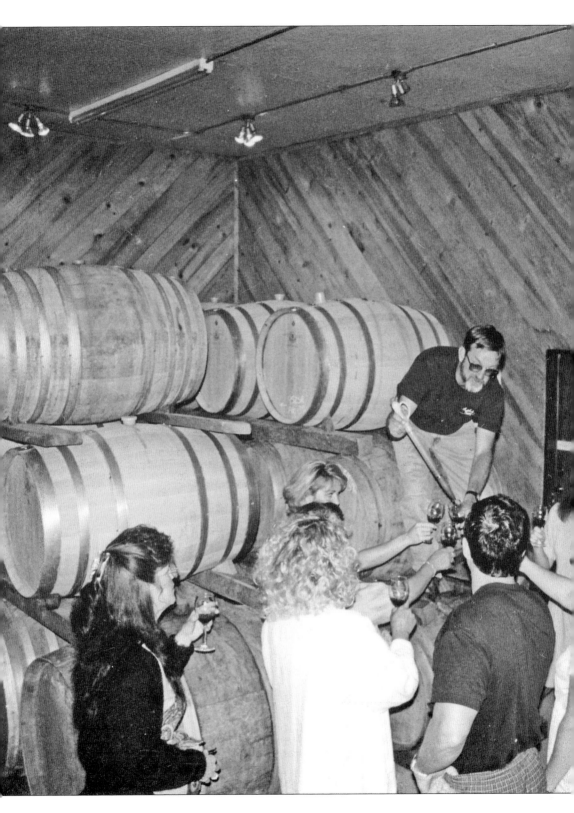

Barrel tasting gives wine enthusiasts a chance to taste and place orders to purchase wine before it is bottled. They reserve wine from a certain barrel, and when it is bottled they purchase it. Here, Leon Sobon hosts a barrel tasting at the Shenandoah Vineyards tasting room. (Courtesy of the Sobon family.)

Bottling machines are used by more than just the winery they belong to. Wineries that do not have their own bottling facilities will often have their wine bottled by neighboring wineries with the necessary facilities. There are also mobile bottlers who bring bottling capabilities to the wineries. Pictured here is the Shenandoah Vineyards bottling machine. (Courtesy of the Sobon family.)

In 1985, Leon Sobon stands next to the bottling machine at his Shenandoah Vineyards cellar. The Sobon family has been involved in every aspect of their winemaking endeavors since they first moved to Amador County's Shenandoah Valley in 1977. (Courtesy of the Sobon family.)

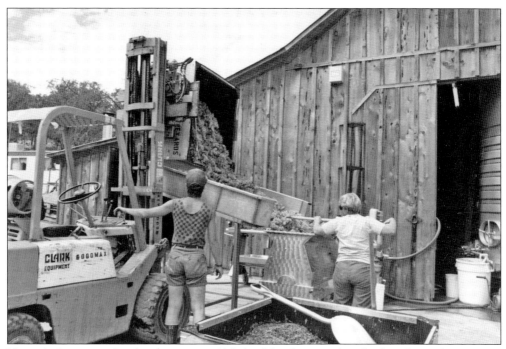

Not only do wineries bottle other wineries' labels, if they have crush pads, they also perform custom crushes. Chatom Vineyards' first crush was custom at the Winterbrook Winery. Since that time, Chatom has built a winery that includes its own crush pad. (Courtesy of Chatom Vineyards.)

During the wine renaissance in the Shenandoah Valley, newly planted vineyards began branching out from the traditional and well-selling Zinfandel. The first vineyard Leon and Shirley Sobon planted was Sauvignon Blanc. Here, the couple is photographed in the tasting room they built themselves. (Courtesy of the Sobon family.)

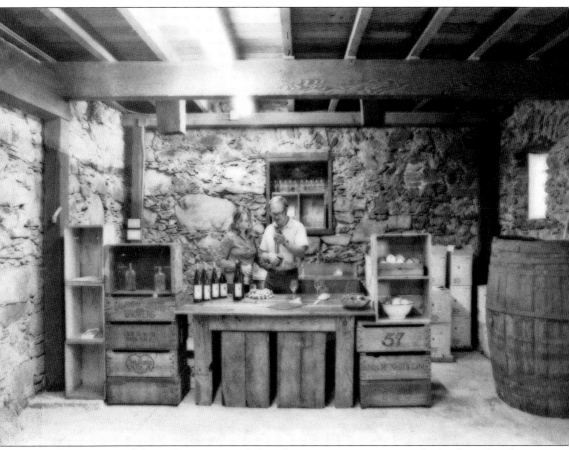

In 1974, Greg and Susan Boeger opened their first tasting room using a plank of wood and two wine barrels for their tasting bar. It was located in the Historic Lombardo Winery, which visitors can still tour today. The winery now has a new tasting room and areas for visitors to enjoy a bottle of wine and picnic next to rock walls built by miners back during the Gold Rush. (Courtesy of the Boeger family.)

Wine tasting brings a lot of visitors to the region, with more coming every year to experience for themselves the wines made from the fruit of the rich soils. The Montevina/Terra D'Oro tasting room, built in the 1970s, still attracts many visitors. The winery boasts a wine club of 1,500 members and a mailing list of 20,000. (Author's collection.)

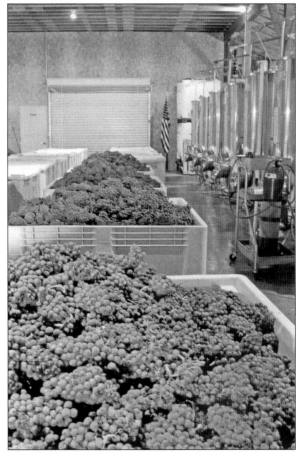

Many wineries have their crush pads and banks of steel fermentation tanks close to the wine tasting room at the winery, giving visitors a chance to not only taste the wine but to tour the facility and see what goes into bringing taste to the bottle. Here grapes wait to be crushed at Mount Brow's winery in Sonora. (Courtesy Mount Brow Winery.)

The wine cavern at Ironstone Vineyards in Murphys took a year to complete, with workers blasting out 10,000 square feet of underground space in which the winery ages some of its wines. The caverns provide a naturally constant 60-degree temperature and 80-percent humidity no matter what the weather is like outside, creating an ideal aging environment without having to pay a high price to create those conditions. Ironstone president Stephen Kautz stands next to the doors leading to the wine cave. (Courtesy of the Kautz family.)

Work crews blast out granite to create the wine cavern at Ironstone Vineyards in Murphys. When it first opened, the family used it as the winery's tasting room and held special events there. (Courtesy of the Kautz family.)

The largest winery complex in the Gold Country region, Ironstone Vineyards began with the wine cavern (doors are seen here) where the first tasting room was located. Since then, it has grown to include a tasting room with a 42-foot-high stone fireplace and historic carved wooden bar, a 1920s pipe organ from Stockton's Alhambra Theater in one of the main event rooms, 14 acres of gardens (including a lake), and an amphitheater that is ranked one of the top 100 in the world by Pollstar. (Courtesy of the Kautz family.)

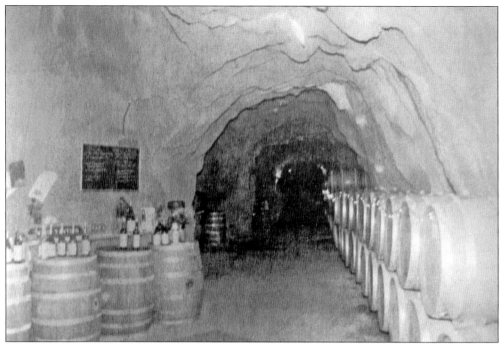

"We put the door up, and that was the first time the cave smelled like wine," said Gail Kautz about the doors to the wine cellar. The large doors were fashioned out of redwood heartwood tanks from the D'Agostini Winery. The tasting room at Ironstone Vineyards winery also features wood from the same tanks along its walls. (Courtesy of the Kautz family.)

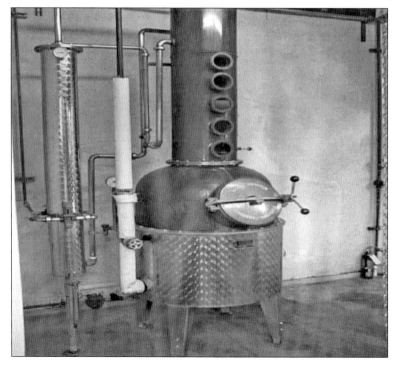

Through the years, home stills were used to make grappa and brandy. Stephen Kautz, president of Ironstone Vineyards, said many locals brought their old stills when the Kautz family began building the winery in Murphys. This still at Ironstone Vineyards is used to make apple wine. (Courtesy of the Kautz family.)

The Gold Country wine region began making award-winning wines early in the area's renaissance. The 1980 Montevina Special Selection Barbera won in 1983 wine competitions, including gold at the Orange County Fair, the Riverside Farmer's Fair, and the Sierra Foothills competition and silver at the Los Angels County Fair. (Courtesy of Terra D'Oro/Montevina Winery.)

Wine labels are as unique and interesting as the people that make what goes in the bottle. Many times a commemorative label is created to celebrate a significant event. Here, Amador Foothill Winery created a label to celebrate its Sangiovese release. The Renaissance-inspired illustration is reflective of the Cervantes classic *Don Quixote*. If one looks closely, owner Ben Zeitman, his wife and winemaker Katie Quinn, and Bill Easton, owner of Terra Rouge & Easton Wines, can be seen. (Courtesy of Amador Foothill Winery.)

BY LINDA LAING

Festa dell'Uva

AMADOR FOOTHILL WINERY

1999

SHENANDOAH VALLEY, CALIFORNIA

SANGIOVESE

ALCOHOL 14.5% BY VOLUME

1999 SANGIOVESE ~ SELEZIONE PRIMO

Our eighth release of estate grown Sangiovese was produced in collaboration with our consultants, Artilio Pagli and Alberto Antonini. Tuscan in style, with lush fruit and refined structure, this special bottling represents the finest expression of our grape growing and winemaking abilities. Enjoy with grilled meats and traditional Italian dishes. Only 191 cases produced.

www.amadorfoothill.com

GROWN, PRODUCED AND BOTTLED BY AMADOR FOOTHILL WINERY, PLYMOUTH, CALIFORNIA BW 4963

CONTAINS SULFITES

GOVERNMENT WARNING: (1) ACCORDING TO THE SURGEON GENERAL, WOMEN SHOULD NOT DRINK ALCOHOLIC BEVERAGES DURING PREGNANCY BECAUSE OF THE RISK OF BIRTH DEFECTS. (2) CONSUMPTION OF ALCOHOLIC BEVERAGES IMPAIRS YOUR ABILITY TO DRIVE A CAR OR OPERATE MACHINERY, AND MAY CAUSE HEALTH PROBLEMS.

PRODUCED AND BOTTLED BY AMADOR FOOTHILL WINERY
PLYMOUTH, CA BW 4963 - CONTAINS SULFITES - 750ML

Alc. 15.6% by Vol.

AMADOR
F O O T H I L L

2010
Shenandoah Valley, California
ZINFANDEL
CLOCKSPRING VINEYARD

Grapes are from Frank Aloiso's 40 year-old organically farmed vineyard. Intense cherry aromas and mouth filling, lingering flavors or raspberries, black cherries and pepper define this classic Amador Zinfandel. Enjoy with barbeque, burgers, pizzas or ratatouille. 425 cases were produced. Contact us at (209) 245-6307, or visit us at www.amadorfoothill.com

Wineries not only make wine but also help educate so their customers get the most out of drinking their fruit of the vine. This label, from a series designed by Amador Foothill Winery, helps wine buyers learn what foods the wine will pair well with by using a herb flower design. It shows that rosemary, which can be used to enhance the flavor of lamb, goes well with Zinfandel, while another label shows a dill flower, which can be prepared with chicken and pairs well with a Sauvignon Blanc. (Both, courtesy of Amador Foothill Winery.)

SAGE
Salvia officinalis

Like the Ferrero Zinfandel, sage is a festive companion to sausage, pork and lamb. Sage-seasoned duck, turkey and game hen are also enjoyable with Zinfandel.

Wine's relationship to food is celebrated in Amador Foothill's series of culinary herb flower labels. Recipes using wine and herbs are available at the winery tasting room.

CONTAINS SULFITES

AMADOR FOOTHILL WINERY
1991
SHENANDOAH VALLEY, CALIFORNIA
Zinfandel
FERRERO VINEYARD
PRODUCED AND BOTTLED BY
AMADOR FOOTHILL WINERY, PLYMOUTH, CA
ALCOHOL 14.6% BY VOLUME BW 4963

1991
Special Selection Zinfandel
Ferrero Vineyard
Shenandoah Valley, CA

HARVEST DATE: 9/22/91
9 Months in American oak
1003 CASES PRODUCED
ACID: 0.68g/100ml pH3.50

This picturesque dry-farmed vineyard has been carefully tended by John Ferrero since 1962. Our resulting wine has distinctive cherry and plum aromas and flavors with black pepper overtones. There is an intriguing balance between the fruit and subtle oak in this rich Zinfandel.

Additional aging will further develop the character and complexity of this classic Zinfandel. Call us if you have any questions (209) 245-6307.

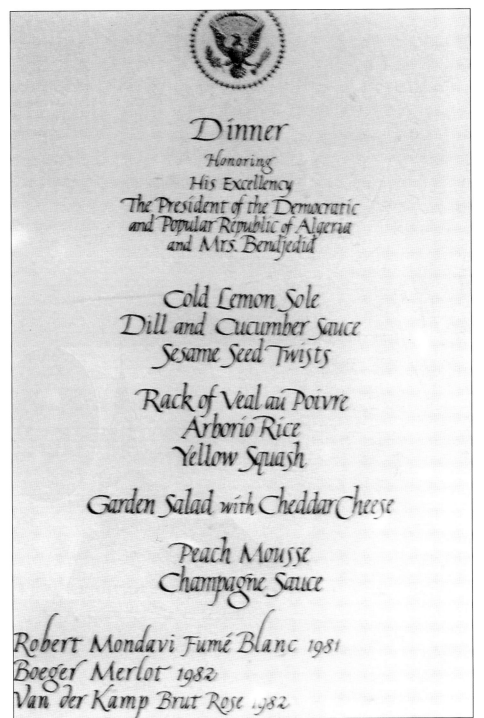

Dinner

Honoring
His Excellency
The President of the Democratic
and Popular Republic of Algeria
and Mrs. Bendjedid

Cold Lemon Sole
Dill and Cucumber Sauce
Sesame Seed Twists

Rack of Veal au Poivre
Arborio Rice
Yellow Squash

Garden Salad with Cheddar Cheese

Peach Mousse
Champagne Sauce

Robert Mondavi Fumé Blanc 1981
Boeger Merlot 1982
Van der Kamp Brut Rose 1982

As time went on, the region's wines become more well known, winning awards and being served at distinguished events. Here, a dinner menu at the White House shows a 1982 Boeger Merlot that was served to the president of Algeria. That year, the Boeger wine was also served at a luncheon honoring the prime minster of Japan. (Author's collection.)

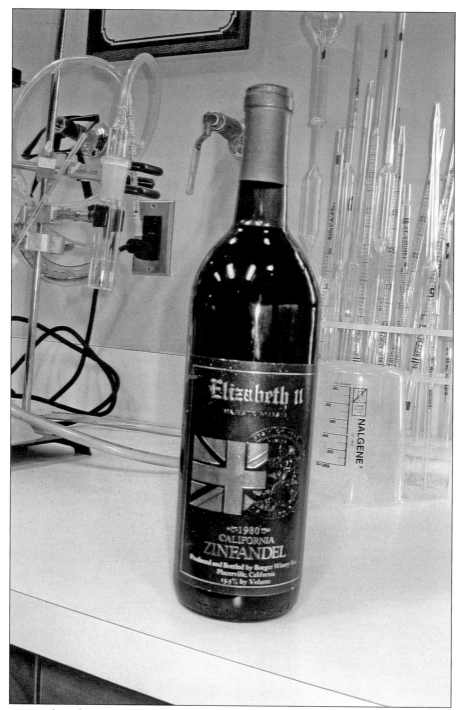

Boeger wines have been served to dignitaries from around the world. In 1980, Pres. Ronald Reagan presented England's Queen Elizabeth II a Boeger Zinfandel bottled especially for her during her visit to California. The wine was served at events she attended in Los Angeles and San Francisco. President Reagan gave a gift of wines made in the United States, including a Boeger Winery wine, to Mikhail Gorbachev while he was visiting the United States. (Author's collection.)

When John James Davis (at right) arrived in the Gold Country from Indiana, he was already a cooper from a stop on his journey in Iowa. First settling in Placerville, he soon moved to the Shenandoah Valley, where he opened his own cooperage, making barrels that can still be seen at the D'Agostini/Sobon Estate Winery. He planted Mission grapes in 1869, with six acres of that planting still being maintained by his great-grandson Ken Deaver Jr. (below). (Both, courtesy of Deaver Vineyards.)

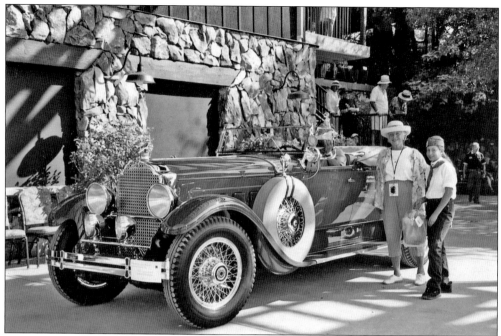

With the Concourse D'Elegance, the Kautz family has the largest annual fundraiser in the Gold Country region. Gail Kautz began the event to support youth in agriculture, such as 4-H and Future Farmers of America. Back in 1993, the event was Wine in the Cavern, featuring opera singers from the San Francisco Metropolitan Opera and dinner in the winery's cellar. Nowadays, the annual Kautz fundraiser for youth in agriculture goes beyond support of 4-H and Future Farmers of America—it also helps young people with scholarships money for their studies of agriculture from the farm to the plate. Below, John and Gail Kautz enjoy the annual event. Above, Gail Kautz stands between a classic car and a 4-H student at the winery's amphitheater. (Both, courtesy of the Kautz family.)

Wineries in the Gold Country are typically family owned and operated. They make a priority of giving back to their communities in many ways. The Sobon family, of Shenandoah Vineyards and Sobon Estate, regularly donates gourmet dinners with wine pairings to charity auctions. Here, the winners of a Junior Achievement fundraiser auction enjoy a meal. (Courtesy of the Sobon family.)

Jeff Myers began working for the Terra D'Oro/Montevina Winery in 1981 as the assistant winemaker. He has served the winery in many capacities and is now the general manager. In the Gold Country, it is not uncommon to see individuals like Jeff stay with a winery for a large part of their career. (Courtesy of Terra D'Oro/Montevina Winery.)

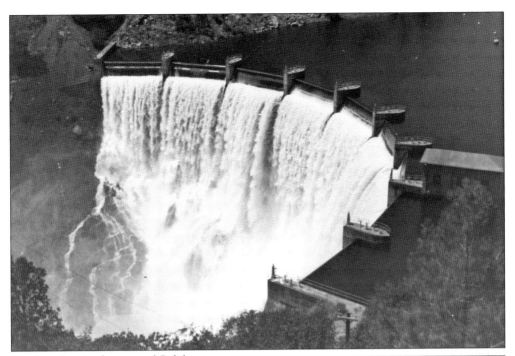

The last dam in the state of California to be built for water storage was completed in 1979. Here, the spillway of New Melones Dam shows the point where the reservoir was filled with water, covering the town of Melones. During low-water years, one can still see the buildings that were part of the town of Melones, where the Pendola Ranch produced about 3,000 gallons of wine during a good year. (Courtesy of the Bureau of Reclamation.)

Award-winning photographer and author of the book *Into the Earth: A Wine Cave Renaissance,* Daniel D'Agostini has taken many photographs of vineyards and wineries throughout the Gold Country. He is the son of Tulio and Kay D'Agostini. He took this photograph of Chatom Vineyards in the 1970s. (Courtesy of Chatom Vineyards.)

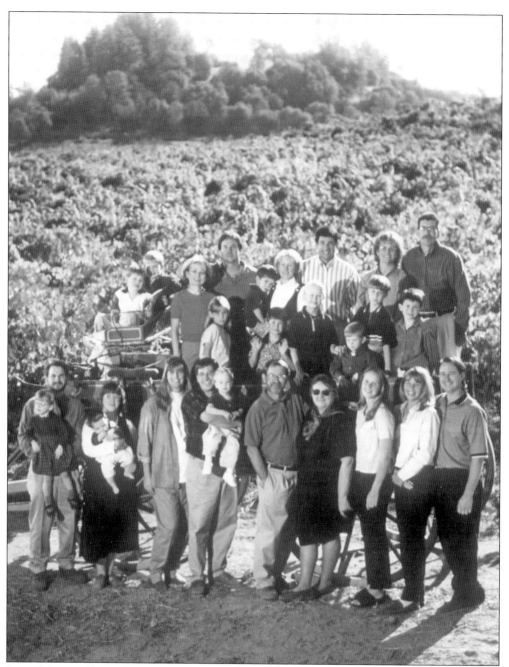

Leon Sobon and his wife, Shirley, moved from Palo Alto to start Shenandoah Valley Vineyards in 1977. The couple brought their six children to the rural county, and they too helped with every aspect of running the winery. Now, it is not uncommon to see the couple's grandchildren working in the tasting room and around the winery during school breaks. Here, three generations of Sobons are photographed in front of one of the family's vineyards. (Photograph by Larry Angier.)

Four

HARVEST

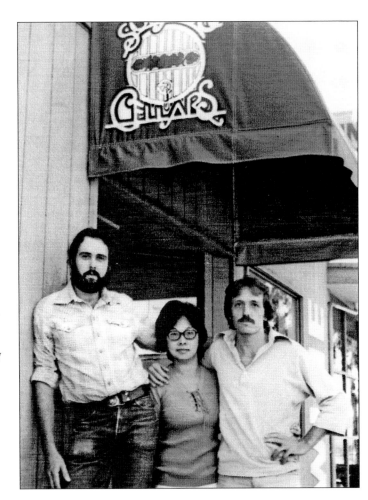

After the first wave of winemakers came to the Gold Country, they were followed by others who caught their vision. They came from a variety of backgrounds with the common goal of making world-class wines. One of those was William Easton (left), founder of Terre Rouge and Easton Wines in the Shenandoah Valley in 1985. He stands along with May Bayley (Ling) and Mike Gleason on the opening day at Solano Cellars, a pioneering wine shop in Berkeley, California, they founded in 1978. (Courtesy of William "Bill" Easton.)

LIST OF WINERIES

NEVADA COUNTY

Avanguardia, Nevada City, 530-274-9482
Coufos Cellars, Rough & Ready, 530-274-2923
Double Oak, Nevada City, 530-292-3235
Indian Springs Vineyards, Nevada City, 530-478-1068
Montoliva Vineyard & Winery, Chicago Park, 530-346-6577
Naggiar Vineyards, Grass Valley, 530-268-9059
Nevada City, Nevada City, 530-265-9463/800-203-9463
Pilot Peak Vineyard & Winery, Penn Valley, 530-432-3321
Sierra Knolls Vineyards, Grass Valley, 530-268-9225
Smith Vineyard, Grass Valley, 530-273-7032
Take Fine Wines, Grass Valley, 530-477-8282
The Solune Vineyard, Grass Valley, 530-271-0990
Truckee River Winery, Truckee, 530-587-4626

PLACER COUNTY

Bonitata Boutique Wine, Auburn, 530-305-0449
Cante Ao Vinho, Lincoln, 530-633-0234
Casque Wines, Loomis, 916-660-9671
Ciotti Cellars, Loomis, 916-534-8780
Cristaldi Vineyards, Loomis, 916-759-1291
Dono dal Cielo, Newcastle, 530-888-0101
Fawnridge Winery, Auburn, 530-887-9522
Fortezza Winery, Auburn, 530-820-3822
Green Family Winery, Auburn, 530-888-8866
Lone Buffalo Vineyards, Auburn, 916-663-4486
Mount Vernon Winery, Auburn, 530-823-1111
PaZa Vineyard & Winery, Auburn, 916-834-0565
Pescatore, Newcastle, 916-663-1422
Popie Wines, Loomis, 916-768-7643

Rancho Roble Vineyards, Lincoln, 916-645-2075
Secret Ravine Vineyard and Winery, Loomis, 916-652-6015
Viña Castellano Winery, Auburn, 530-889-2855
Wise Villa Winery, Lincoln, 916-543-0323

EL DORADO COUNTY

Auriga Cellars, Placerville, 530-647-8078
Boeger Winery, Placerville, 530-622-8094/800-655-2634
Busby Cellars, Fair Play, 530-344-9119
Cantiga Wineworks, Fair Play, 530-621-1696
Cedarville Vineyard, Fair Play, 530-620-9463
Cielo Estate, Shingle Springs, 530-672-8575
Chateau Rodin, Placerville, 530-622-6839
Colibri Ridge Winery & Vineyard, Fair Play, 530-620-7255
Crystal Basin Cellars, Camino, 530-647-1767
Fenton Herriott Vineyards, Placerville, 530-642-2021
Fitzpatrick Winery & Lodge, Fair Play, 530-620-3248/800-245-9166
David Girard Vineyards, Placerville, 530-295-1833
Gold Hill Vineyard & Brewery, Placerville, 530-626-6522
Grace Patriot Wines, Placerville, 530-642-8424
Holly's Hill, Placerville, 530-344-0227
Illuminare, Camino, 530-306-3873 (tasting room, 530-647-1884)
Jodar Vineyards & Winery, Camino, 530-644-3474
Latchum Vineyards, Mount Aukum, 530-620-6642/800-750-5591
Lava Cap Winery, Placerville, 530-621-0175
Madrona, Camino, 530-644-5948/800-230-7662
Miraflores, Placerville, 530-647-8505
Charles B. Mitchell Vineyard, Fair Play, 530-620-3467

Mount Aukum Winery, Somerset, 530-620-1675/800-591-WINE

Narrow Gate Vineyards, Placerville, 530-644-6201

Nello Olivo Wines, Placerville, 530-409-5603

Perry Creek Winery, Fair Play, 530-620-5175/800-880-4026

Saluti Cellars, Somerset, 530-626-0800

Shadow Ranch Vineyard, Fair Play, 530-620-2785

Sierra Oaks Estates, Mount Aukum, 530-620-7079

Sierra Vista Vineyards & Winery, Placerville, 530-622-7221/800-946-3916

Single Leaf Vineyards & Winery, Fair Play, 530-620-3545

Skinner Vineyards & Winery, Somerset, 530-620-2220

Synapse Wines, Placerville, 530-626-9463

Windwalker Vineyard, Fair Play, 530-620-4054

Wofford Acres, Camino, 530-626-6858/888-WAV-Wine

AMADOR COUNTY

Amador 360 Winery Collective, Plymouth, 209-267-4355

Amador Cellars, Plymouth, 209-245-6150

Amador Foothill Winery, Shenandoah Valley, 209-245-6307

Andis Wines, Shenandoah Valley, 209-245-6177

Avio Vineyards and Winery, Sutter Creek, 209-267-1515

Bella Piaza Winery, Shenandoah Valley, 209-245-4600

BellaGrace Vineyard, Sutter Creek, 209-267-8053

Borjon Winery, Plymouth, 209-245-3087

Bray Vineyards, Shenandoah Valley, 209-245-6023

C.G. DiArie Vineyard and Winery, Shenandoah Valley, 209-245-4700

Charles Spinetta Winery & Wildlife Art Gallery, Plymouth, 209-245-3384

Cinque Tasting Room, Sutter Creek, 209-267-0900

Clos du Lac Cellars/Greenstone Winery, Ione, 209-274-2238

Convergence Vineyards, Plymouth, 209-245-3600

Cooper Vineyards, Shenandoah Valley, 209-245-6181

Deaver Vineyards, Plymouth, 209-245-4099

Dillian Wines, Shenandoah Valley, 209-245-3444

Dobra Zemlja Winery, Shenandoah Valley, 209-245-3183

Driven Cellars, Plymouth, 209-245-4545

Drytown Cellars, Drytown, 866-379-8696

Feist Wines, Amador City, 209-267-8020

Helwig Vineyards & Winery, Plymouth, 209-245-5200

Il Gioiello Winery/Morse Wines, Fiddletown, 209-245-3395

J. Foster Mitchell, Shenandoah Valley, 209-245-6677

Jeff Runquist Wines, Plymouth, 209-245-6282

Karly Wines, Shenandoah Valley, 800-654-0880

Karmere Vineyards and Winery, Shenandoah Valley, 209-245-5000

Nine Gables Vineyard, Shenandoah Valley, 209-245-3949

Nua Dair Vineyards, Ione, 209-245-5567

Renwood Winery, Plymouth, 800-348-8466

Sera Fina Cellars, Plymouth, 209-245-4300

Shenandoah Vineyards, Shenandoah Valley, 209-245-4455

Sierra Ridge Vineyards, Sutter Creek, 209-267-1316

Sobon Estate, Shenandoah Valley, 209-245-6554

Stonehouse Vineyards & Winery, Shenandoah Valley, 209-245-6888

Story Winery, Shenandoah Valley, 800-713-6390

Tanis Vineyards, Ione, 209-274-4807

Terra d'Oro/Montevina Winery, Plymouth, 209-245-6942

Terre Rouge and Easton Wines, Fiddletown, 209-245-3117

TKC Vineyards, Shenandoah Valley, 888-627-2356

Villa Toscano, Shenandoah Valley, 209-245-3800

Vino Noceto, Shenandoah Valley, 209-245-6556

Wilderotter Vineyard, Shenandoah Valley, 209-245-6016

Young's Vineyards, Shenandoah Valley, 209-245-3005

CALAVERAS COUNTY

Allégorie Tasting Room, Murphys, 209-728-9922

Ayrael Vieux, Douglas Flat, 209-728-8493

Black Sheep Winery, Murphys, 209-728-2157

Bodega del Sur, Murphys, 209-728-9030

Brice Station Winery, Murphys, 209-728-9893

Broll Mountain Vineyards, Murphys, 209-728-9750

Chatom Vineyards, Douglas Flat, 209-736-6500/800-435-8852

Chiarella Wines, Murphys, 209-728-8318

Coppermine Winery, Vallecito, 209-736-2305

Four Winds Cellars, Vallecito, 209-736-4766

Frog's Tooth Vineyards, Murphys, 209-728-2700

Hatcher Winery, Murphys, 209-605-7111

Hovey Winery, Murphys, 209-728-9999

Indian Rock Vineyards, Murphys, 209-728-8514

Irish Vineyards, Vallecito, 209-736-1299

Ironstone Vineyards, Murphys, 209-728-1251

La Folia Winery, Murphys, 209-728-5298

Lavender Ridge Vineyard, Murphys, 209-728-2441

Metate Hill Vineyards, Murphys, 209-728-8983

Metzger Wines, San Andreas, 209-754-1010

Milliaire Winery, Murphys, 209-728-1658

Newsome-Harlow Wines, Murphys, 209-728-9817

Prospect 772 Wine Company, Angels Camp, 209-736-9361

Renegade Winery, Mokelumne Hill, 209-286-1041

Renner Winery, Murphys. 209-728-2314

Stevenot Winery, Murphys, 209-728-3485

Tanner Vineyards, Murphys, 209-728-8229

Twisted Oak Winery, Vallecito, 209-736-9080

Val du Vino Winery, Murphys, 209-728-9911

Villa Vallecito Vineyards, Vallecito, 209-743-9384

Renegade Winery, Mokelumne Hill, 209-286-1041

Zucca Mountain Vineyards, Murphys, 209-736-2949

TUOLUMNE COUNTY

Gianelli Vineyards, Jamestown, 209-532-0414

Indgeny Reserve, Sonora, 209-533-9463

La Bella Rosa Winery, Sonora, 209-533-8668

Mount Brow Winery, Sonora, 209-532-8491

BIBLIOGRAPHY

Adams, Leon D. *California Wine Industry Affairs: Recollections and Opinions*. Berkeley: The Bancroft Library, University of California, Regional Oral History Office, 1990.

———. *Revitalizing the California Wine Industry*. Berkeley: The Bancroft Library, University of California, Regional Oral History Office, 1974.

Calaveras County, California, Soil, Climate and General Resources. San Andreas, CA: Calaveras County Board of Trade, 1860.

Calaveras County: Illustrated and Described Showing Its Advantages for Homes. Oakland: W.W. Elliott & Company, 1885.

Carosso, Vincent P. *The California Wine Industry 1830–1895: A Study of the Formative Years*. Berkeley: UC Press, 1976.

Cenotto, Larry. *Logan's Alley Amador County Yesterdays in Pictures and Prose, vol. I–V*. Jackson, CA: Cenotto Publications, 1988–2006.

Costa, Eric J. *Gold and Wine, A History of Winemaking in El Dorado County*. El Dorado, CA: El Dorado Winery Association, 2010.

———. *Old Vines: A History of Winegrowing in Amador County*. Jackson, CA: Cenotto Publications, 1994.

Daily Alta California, San Francisco.

Denman, J.L. *A Brief Discourse on Wine, How to Choose It and How to Use It*. London: Charles Griffin and Company, 1861.

Hardy, Thomas. *Notes on Vineyards, America & Europe*. Adelaide: L. Henn & Co., 1885

Husmann, George. *Grape Culture and Wine Making in California*. San Francisco: Payot, Upham & Co., 1888.

Lang, Herbert O. *A History of Tuolumne County, California*. San Francisco: B.F. Alley, 1882.

Mason, J.D. *History of Amador County*. Oakland: Thompson & West, 1881.

Pacific Rural Press, San Francisco.

Placer Herald, Auburn, CA.

Sacramento Daily Union.

Sioli, Paolo. *Historical Souvenir of El Dorado County, California, with Illustrations and Biographical Sketches of Its Prominent Men & Pioneers*. Oakland: Paolo Sioli, 1883.

Trinchero, Louis, and Carole Hicke. *California Zinfandels, a Success Story*. Berkeley: The Bancroft Library, University of California, Regional Oral History Office, 1992.

A Volume of Memoirs and Genealogy of Representative Citizens of Northern California, Including Biographies of Many of Those Who Have Passed Away. Chicago: Standard Genealogical Publishing Co., 1901.

Wooten, Kimberly and R. Scott Baxter. *Shenandoah Valley and Amador County Wine Country*. Charleston, SC: Arcadia Publishing, 2008.

www.archives.org

www.cagenweb.com

www.cdnc.ucr.edu

www.corkforest.org

www.folsomhistorymuseum.org

www.house.gov

www.openlibrary.org

www.winefiles.org